CRAZY WACKY THEME RESTAURANTS

CRAZY WACKY
THEME
RESTAURANTS

TOKYO

BY LA CARMINA

MARK BATTY PUBLISHER NEW YORK CITY

Acknowledgements

To my intern, Ayako Chikushi – I don't know what I would have done without you! Your enthusiasm and tireless hours have made this project possible.

To my Tokyo spooks – thank you for your friendship, inspiration and unexpected degree of participation in the shoots (your costumes were phenomenal!): James Blumer, Victoria Brown, Tiffany Godoy, Mihoko Hayashi, B. Jevanael, Lang Leav, Lauren Levitt, Patrick Macias, Jim McGee, Mayumi Otani, Joseph Pastula, Lady Raisu, Nathan Reaven, Tim Rudder, Count de Sang, Sebastien Van Damme, Somnium in Tenebris.

To the fam, for unconditionally supporting my bizarre lifestyle and adventures in book writing: my parents, Elizabeth Wurtzel, Melissa Rundle, Ronan Farrow and our beautiful genius son Basil Yuen Farrow.

To my rock star agent, Lindsay Edgecombe at Levine Greenberg, and to author Bryant Terry for introducing us. To Buzz Poole and Christopher D Salyers at Mark Batty Publisher for welcoming me to the team.

And to my dear blog readers at lacarmina.com, for your continuous feedback and (^___^)/. In the words of Placebo, "Without you, I'm nothing."

Domo arigato gozaimasu!

Table of Contents

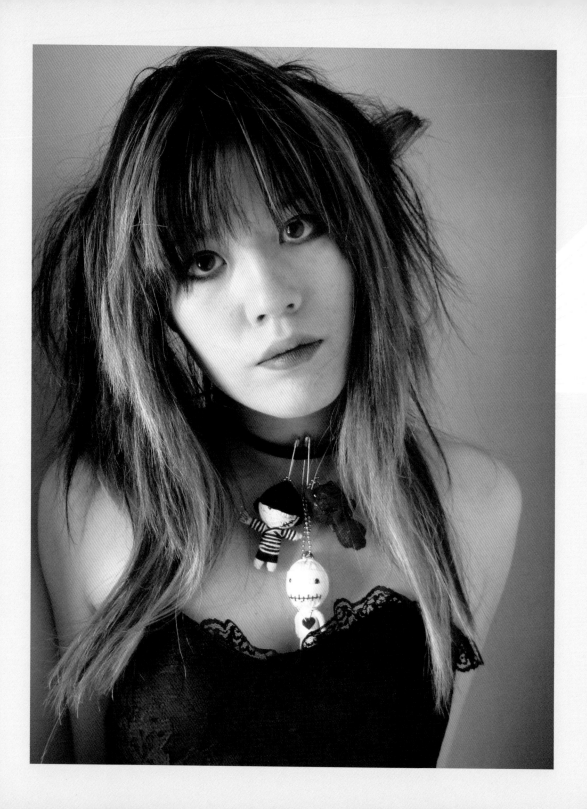

Introduction

If you grew up in North America, you're probably used to rolling your eyes at the gimmick restaurants popular with the young and the trashy. My own experience was particularly traumatic. It began with birthday parties at Chuck E. Cheese: there's a photo of me scowling next to mechanical dogs miming (out of synch) to the Beach Boys. On a trip to Vegas, I was driven to such anxiety by a Medieval dinner show – more so by the giant broccoli on my plate than the fake blood in the arena – that I forced my entire family to walk out. At age ten, an encounter with gummy pasta at the Hard Rock Café ensured my first visit was my last. A Rainforest Café and T.G.I. Friday's opened in a local mall, but at that point, I was reading Poe and had no stomach for fake thundershowers or listless waiters in smiley-buttoned vests...

So I stayed away, resigned that my unquenchable thirst for bizarre – my kitsch-fix, if you will – would have to be met through Visual Kei (Japanese glam metal) concerts and cybergothic nightcrawls.

But when I visited Tokyo a few years ago, a friend told me about a Jesus-themed café (page 51) where one could simulate the experience of "getting trashed in St. Peter's." I booked a table at Christon the next day and experienced something close to a spiritual revelation. From that day forth, I was a theme restaurant convert. I made pilgrimages all over Japan and played the prophet, blogging fervently about my favorites... which eventually led to the genesis of this book.

How did Tokyo's wild, crazy theme restaurants come to be? The trend started with a whimper: a Hard Rock Café established in 1983. A marketing company called H-Y System latched onto this middling idea – of a restaurant with unusual décor – and jacked it to Celine-Dion-in-Vegas levels. Alcatraz B.C. (now defunct) opened in 1998 and offered the elegant experience of dining in a haunted prison. Customers were handcuffed, shut into cells, fed penis-or drug-themed cocktails, and finally attacked by escaped lunatics in masks. It was a rip-roaring success.

Japanese restaurateurs smelled potential and created their own fantasy diners. The Lock-Up and Christon arrived early on, and both now have branches throughout Japan. Diamond Dining added elaborately-decorated food and special events to the mix; the company's brainchildren include Vampire, Alice in Wonderland, Phantom of the Opera and Princess Heart.

The surge of theme restaurants coincided with the first maid cafés that opened in Akihabara around 2000. There are now thirty or more in this district alone, in addition to cosplay (costume-play) cafés of every stripe: mother, sister, butler, schoolboy, drag, prehistoric, robot.

These eateries are on a different planet from their tepid Western relatives. The theme isn't suggested – it's rammed up your nose. Expect trick entrances, Klaus Nomi costumes, festooned food, heavy petting and more than a few B-movie non-sequiturs. How about ninjas screaming in your ear, a French maid whacking you across the face or a man in a frog suit pumping urine out of a cherub?

Only in Japan, as the saying goes. What makes Tokyo a breeding ground for fantasy restaurants? The Japanese have a high tolerance for *kawaii* (cute) and kitsch: witness Pokemon charms dangling from the cell phones of businessmen. Dressing up is a national pastime, from seasonal festivals to Harajuku street style to cosplay. And the sensory overload of living in Tokyo – think frantic para-para and flashing neon screens at the famous pedestrian crossing – makes the Japanese amenable to a more stimulating dining experience.

Some of these themes may seem difficult to swallow, or even blasphemous, but there's no intent to offend. For the Japanese, master-servant relations and Christian imagery aren't loaded with the same meaning as in the West. Sure, the maids wear short skirts and some offer spoon-feeding or hand massages, but nothing acutely sexual goes on - at least nothing more than what you find at Hooters.

Here's the deal with theme restaurants: it's like putting a man in a sequined red dress for the first time. There are sparkles and a skirt involved – you can't get around these facts. So if you're the bloke in question, you can moan "this is stoopid" and cover your crotch. Or you can work it. Roll with it. Own it like you're in fishnets at *Rocky Horror*. Attitude will make or break you, and it's precisely what will make theme dining a drag... or drag queen fabulous.

So I invite you to open your mind and dive with me into the kitschy wonderland of theme dining. May you emerge with puncture marks on your neck and a pumpkin on your head!

Chapter 1
Spook-Tastic

Alcatraz E.R.

Alcatraz and The Lock-Up are two of the most hardcore theme restaurants in Tokyo, if not the planet. I'm reluctant to bring Man Heaven (page 14) or the J-Goths (page 16) into these B-horror jail simulations. You never know how someone will react to being humped by monsters to the soundtrack of disco – and I don't want to risk becoming single and friendless.

I shrewdly decided to visit these restaurants with distant acquaintances. A family friend's son was in Tokyo with his girlfriend and randomly contacted me on Facebook. I haven't seen or spoken to this kid since we were twelve years old and playing Street Fighter in the basement. I invite them to dinner at Alcatraz in Shibuya.

As soon as I spot them, I know this isn't going to go over well. We'll call this pair Wilburn and Lorraine because while they're in their mid-twenties, they give off the vibe of a retirement home. They mumble hello and tell me they spent the afternoon shopping at Shibuya 109.

"Ooh!" I gush, "I was there yesterday! I want to be Goth Sailor Moon for Halloween – well, for one of my costumes, at least – so I found this runched black dress with a giant bow across the front. I figure I can add the sailor collar and draw a cobweb on my face, but the dress is sort of obscenely short and I don't think I'd wear it again... do you think I should get it?"

Blank eyes, frightened smiles. I try again:

"So... did you buy anything today?"

"No. The clothes are too weird here."

Scratch any prospects of witty dinner conversation. Thankfully, Alcatraz has plenty of distractions. As soon as the elevator doors open, the theme begins: flashing red lights, a straight-jacketed corpse. Inmate-patients must put their hands between bars and press their blood type to enter.

A nurse in a pink uniform and cap checks off our reservation. She takes out a pair of handcuffs and the

Harvest Bldg 2F, 2-13-5 Dogenzaka, Shibuya-ku, Tokyo, Japan
Nearest station
Shibuya
Open
Mon-Thurs & Sun (5pm-12am), Fri-Sat & holidays (5pm-4am)
Telephone
03-3770-7100 (reservations recommended)
URL
www.alcatraz.hy-japan.com

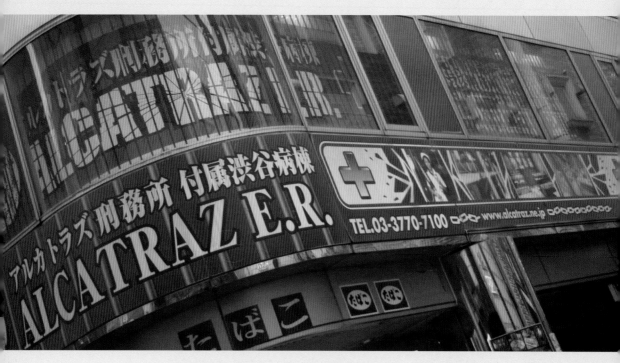

retirees find fault with anything and everything that arrives. The cocktails look like IV drips, syringes, chemical flasks or false teeth? "Overpriced, way too sweet and you can't taste any alcohol." The Penis Sausage and Dead Chicken Feet? "Overpriced and dry, and the wiener isn't big enough."

I insist on the Russian Roulette appetizer; five of the octopus balls are "safe" and the sixth is filled with wasabi. It's down to Wilburn and me. I pop mine into my mouth... nothing. Wilburn stares glumly at his.

Thankfully, the lights go out and a siren wails over a cheerful announcement: "Sumimasen! Please be informed that the monsters have escaped!" First come nurses with guns who blast blanks into our faces. Then, a ghost in a blood-stained lab coat climbs the bars and swipes at diners in the upper cages. He yanks open our cell door and grabs Lorraine by the hair. She forces a grin that quickly dissolves into a scowl. Finally, the doctors chase away the monsters with giant plastic hammers. Wilburn clears his throat and announces their departure, but there's no way I'm missing the Emergency Room Show.

Before long, the speakers are blaring disco music. A monster in a glow-in-the-dark Jason mask drags out the birthday boy – from a party in the X-Ray Room – and dumps him in a wheelchair. His conspirator pins the boy to the ground and humps his left leg. Jason pushes up the boy's shirt and tickles his nipples with plastic slippers.

Wilburn sure made the wrong decision, I think to myself. Instead of watching TV in bed, he could be having his butt prodded with a giant syringe right now...

Flashing red lights foreshadow the peril within...

Crazy, Wacky Theme Restaurants

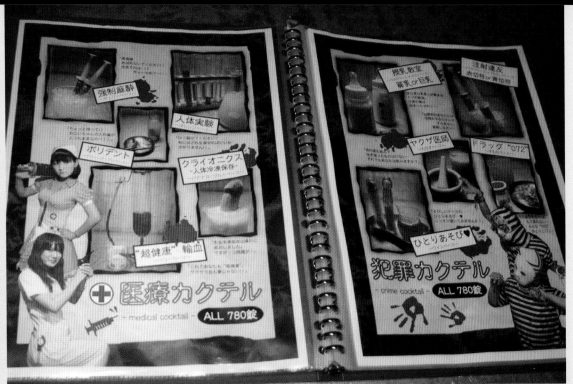

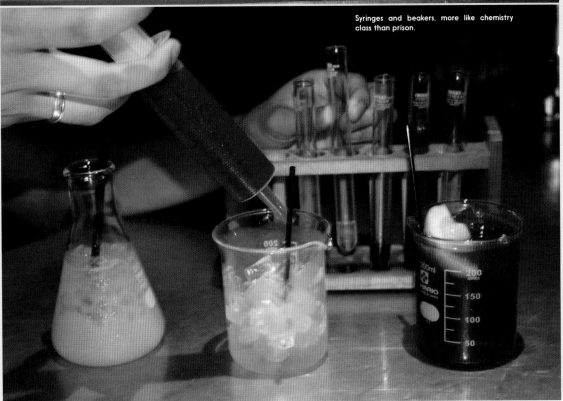

Syringes and beakers, more like chemistry class than prison.

The Lock-up

(Five locations in Tokyo)
Oriental Wave 5F, 5-17-13,
Shinjuku-ku, Tokyo, Japan
Nearest station
Shinjuku
Open
Mon-Thurs (5pm-1am),
Fri-Sat (5pm-5am),
Sun (5pm-12am)
Telephone
03-5292-5516
(reservations recommended)
URL
http://r.gnavi.co.jp/g528910/

Victoria was vacationing in Tokyo and wanted to meet up. She was a law school classmate but I barely knew her. Nonetheless, I invited her to participate in my second incarceration at The Lock-Up.

The day before our dinner, I run into Victoria in Shibuya. She gushes about my blog and says she's very much into Japanese subcultures. Oh really? I decide to test her. She follows me into the audio-visual megastore, Tsutaya. Up the escalator. Past the little black curtain. Into the porn section.

"Behold," I sweep the air with my arm, "You have entered Willy Wonka's Chocolate Factory... for sex! Old people, fat people, fetishes all! Here's a shelf for anime porn, and the one behind it holds gangbangs. Look, there's a new DVD that pairs women with robots..."

Victoria laps it up, running her fingers over the pixilated genitals in every section. She spends a good ten minutes looking at the subway molestation videos. Okay, I think to myself, this bodes well for tomorrow night.

The horror prison theme begins before you reach your metal-slab table: an undead Oscar the Grouch slams open his trash can and tries to grab me with his claws. I quickly slip my hand under the guillotine and a secret door slides open.

Victoria gladly holds out her wrists to the medieval hostess wielding silver manacles. We are assigned cell #13. Our prison-striped waiter recommends the cocktail with a floating eyeball. Once again, it's too sweet and lacking in alcohol. Our cell block is almost entirely filled with birthday parties and gatherings of friends. There are more than a few drunken businessmen. "This must be a jail for white collar criminals," Victoria quips.

A police woman doles out our Rice Krispies ration into a stainless steel bowl and slams the cell shut. Then the lights flicker and Queen's "We Will Rock You" blasts at full volume. Send in the monsters! Victoria squeals and I scare away her masked attackers with my camera flash.

"Frankenstein grabbed my boob!" she gasps.

"What?"

"He strangled me with his chain and groped me with his other hand!"

"I guess that's a... perk of the job."

"I suppose so!"

There's only one way to top a monster molestation. We follow the exit sign marked "Heaven" and spend the rest of the night downing bottles of sake.

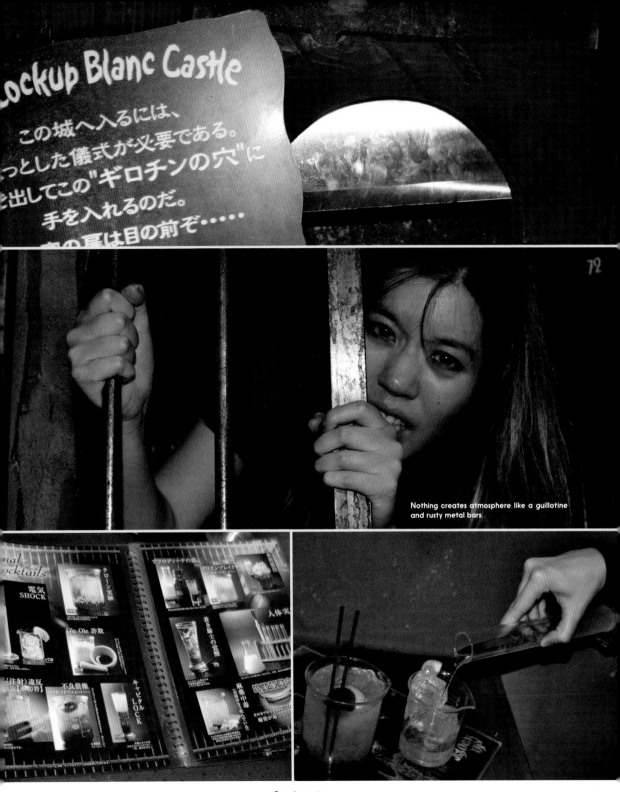

Lockup Blanc Castle

この城へ入るには、
ちょっとした儀式が必要である。
手を出してこの"ギロチンの穴"に
手を入れるのだ。
城の扉は目の前ぞ‥‥‥

Nothing creates atmosphere like a guillotine and rusty metal bars.

Ninja

Ninja Restaurant
Akasaka Tokyu Plaza 1F,
2-14-3 Nagatacho,
Chiyoda-ku, Tokyo, Japan
Nearest station
Akasaka-mitsuke
Open
Mon-Fri (5pm-2am),
Sat-Sun (5-11pm)
Telephone
03-5157-3936
(reservations required)
URL
www.ninjaakasaka.com

I came across his photo on my friend's Facebook album; it was a set from her stay in Tokyo and the caption was: "My interpreter." I expected him to be some glasses-wearing meekling with a briefcase. But no: Jimi happened to be a lovely Gothic pretty-boy, a mix of Ziggy Stardust and Marilyn Manson who models and plays bass in a Visual Kei rock band. "I want one of those!" I commented. She dutifully introduced us by email.

I find him in front of the Asakasa station map. Tall, with blue eyes and high cheekbones – "Man Heaven" is an apt description. Casual conversation leads to a diamond-shaped sign, which brings us inside a building, but the doors are nailed shut.

It dawns on us that finding the ninja's hideout is part of the experience. We adopt their behavior, which – from what we gleaned from movies – means dramatic hand gestures against a long black wall. Man Heaven poses, and then topples into a hidden sliver. I run over and he pokes out his pretty face. "Looky, I found us a ninja!"

She's dressed in a *shinobi shozoku*, the loose mummy wrap that all ninjas wear in movies. All of a sudden, her hooded partner leaps out from behind a curtain and nearly knocks us over, yelling "HAIIIIIIII!"

We are led through a snaking path that looks like it was burrowed into a mountain. It's dark and the stone steps are irregular, and my three-inch doll heels aren't exactly made for spelunking. The ninja halts at a barred opening, behind which there is a treasure chest full of gold. More ups and downs and twists and turns. Lush foliage and the sound of dripping water. "Uh oh," warns the ninja, "we've reached a bottomless pit. How will we make it across?" The gap seems narrow enough to jump with a running start, but I'm not about to make that suggestion. "On the count of three, clap your hands and yell NINJA!" he orders.

A drawbridge lowers, across which is a forest hideout straight out of feudal Japan. Our guide slides open one of the many bamboo doors, revealing a nook for two. He bows and points at a fox drawing hanging from the cobblestone wall: "If you get lost, yell *KITSUNE*!"

The yelling is far from over. "HAI!" – a new ninja spreads open a black scroll that turns out to be the menu. We skip the aloe beauty cocktails in favor of the alcoholic ones and they are beautifully presented: a goldfish in a bowl, a butterfly over a pond. I drop a chopstick. A ninja runs over with a new set: "HAI!"

"Whoa, they're watching us closely!" Man Heaven remarks.

"We'd better be careful about what goes on in here," I smile.

The boy tells me about his band – he's currently the only foreigner in Visual Kei, a glam rock meets Spinal Tap genre – and his modeling work. I photograph him with octopus ink throwing stars, a blazing conch dish, stone soup prepared at the table. He doesn't need to pretend to enjoy the meal.

We're a few paces outside the restaurant when a ninja rushes out to deliver le dernier cri – "HAI!" – and unfurl a giant "Please Come Again" scroll. We do the shoegaze at the subway entrance. I didn't get to try out all my ninjutsu on him. Still, I rode home satisfied. I only had to wait until the following weekend, when our adventure continued at the Jesus restaurant (page 51).

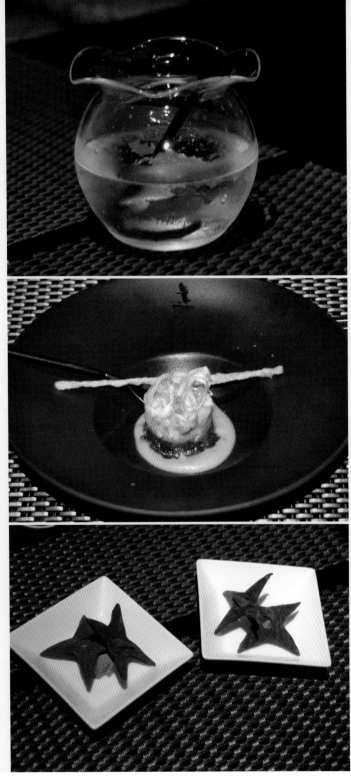

From top to bottom: hot pepper and shochu "goldfish bowl" cocktail; tuna, vinegar, and avocado tartar; ninja star crackers dyed with octopus ink.

15

Vampire Café

**La Paix Bldg. 7F, 6-7-6 Ginza,
Chuo-ku, Tokyo, Japan
Nearest station**
Ginza
Open
Mon-Thurs (5pm-midnight),
Fri-Sat (5pm-5am),
Sun & holidays (5-11pm)
Telephone
03-3289-5360
(reservations required)
URL
www.diamond-dining.com/
vampire

During my two months in Tokyo working on this book, I fell in with a group of fellow twenty-somethings – some Japanese, some *gaijin* (foreigner) – who shared my nocturnal, theme-themed proclivities. I call them the "J-Goths" because the subculture is distinctly Japanese: from the music (EBM/darkwave) and fashion (neo-Victorian/Gothic Lolita) to the morbidly-themed cafés.

At a monthly Goth/fetish night called Midnight Mess, I met a vampire named Count de Sang, granted he was wearing prosthetic fangs and color contacts and a wig, and he wasn't really a Transylvanian aristocrat but an American teaching in Japan – but did it matter? Nobody looked more at home sipping red wine inside Ginza's Vampire Café.

The J-Goths and I put on our finest mourning garb for a blood-feast at the restaurant. The Draculean décor includes a life-size coffin and illuminated hemoglobin floor, and diners pick at crucifix-shaped appetizers with chopsticks – but the campiness is offset by the elegant Baroque seating under red velvet curtains, the strains of a harpsichord, and French maids that swoop over at the tinkle of a gold bell.

I'm always interested in how Goths are "born into darkness," if I may steal a line from Anne Rice's *Interview with the Vampire* – so I pick up my quill and dip it into Count de Sang's vein.

"When did the Japanese Goth aesthetic bite you?"

"I discovered anime in middle school, and it wasn't long until this led me to J-rock music – precisely, Visual Kei. I was drawn to the darkly elegant and androgynous style of Mana, guitarist of Malice Mizer. There I found a world of Gothic illusionary romance, graceful and refined, yet with a madness lurking deep within that thirsted for blood."

"And eventually, your studies brought you to Japan."

"Here, at last, I found expression for my Neo-Victorian Gothic sensibilities. Vampire Café is one such example."

"How did you discover the restaurant?"

"An article in the *Gothic & Lolita Bible* supplied me with the location. After watching Mana perform live for first time, I thought that there could be no better way to extend the evening than by dining amidst the candles and chandeliers of that mysterious establishment. I have returned several times since."

"I noticed that you are friends with some of the servers."

"I would see them at the same club nights. Working at Vampire Café lets them enjoy the beauty of darkness in their daily lives – just as I listen to classical music, drink English tea, smoke a pipe and read Victorian literature."

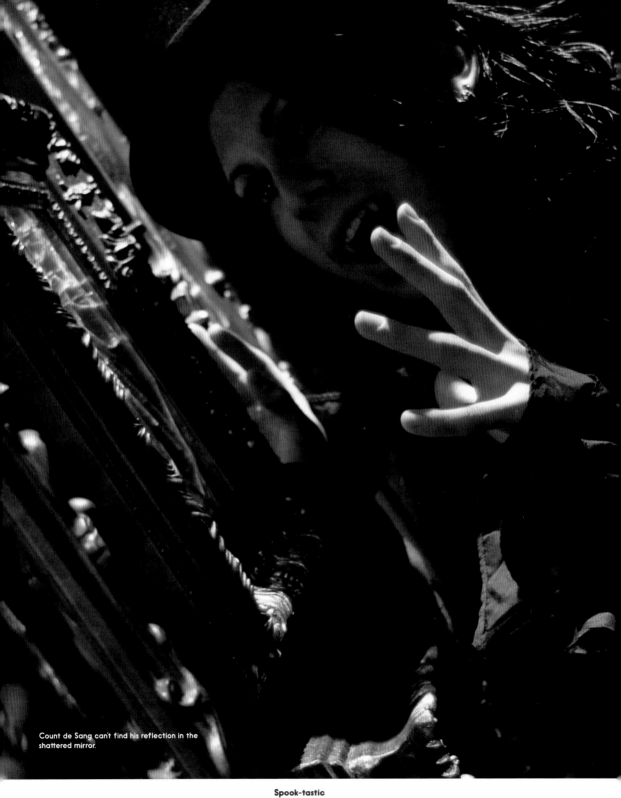

Count de Sang can't find his reflection in the shattered mirror.

"Do you think a vampire-themed restaurant is an 'only in Japan' type of experience?"

"I would say so. In college, I studied the ways the Japanese have assimilated Western Gothic and appropriated it as their own unique concept. The imagery is taken at face-value, and this freedom is visible in manifestations such as Vampire Café."

"Christon Café's religious decor (page 51) might be another example of images divorced from cultural context?"

"Indeed, and it is another favorite destination of mine."

"My dear Count, I thank you for your time and for accompanying me to Vampire Café."

"The pleasure is mine, my dear Lady. Good evening."

Blood isn't on the menu, but it's splattered all over the glowing red floors.

Crazy, Wacky Theme Restaurants

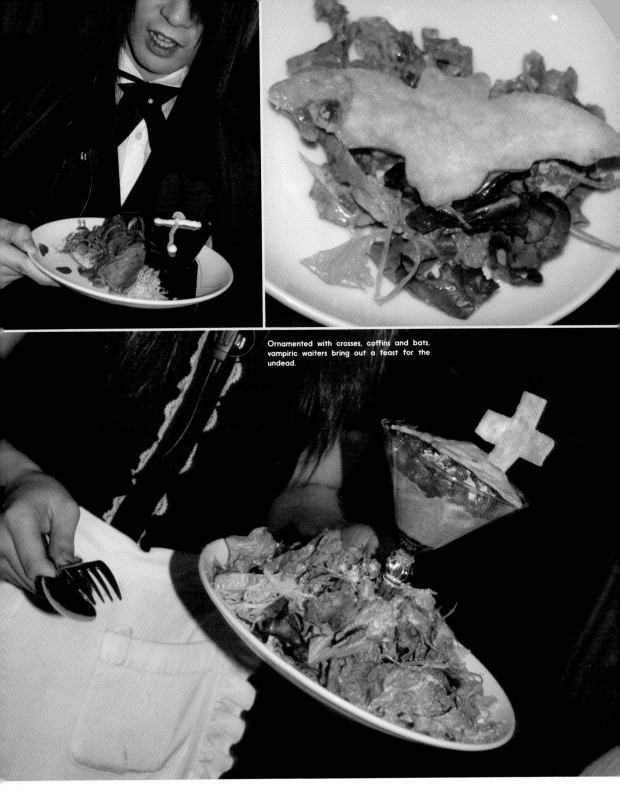

Ornamented with crosses, coffins and bats, vampiric waiters bring out a feast for the undead.

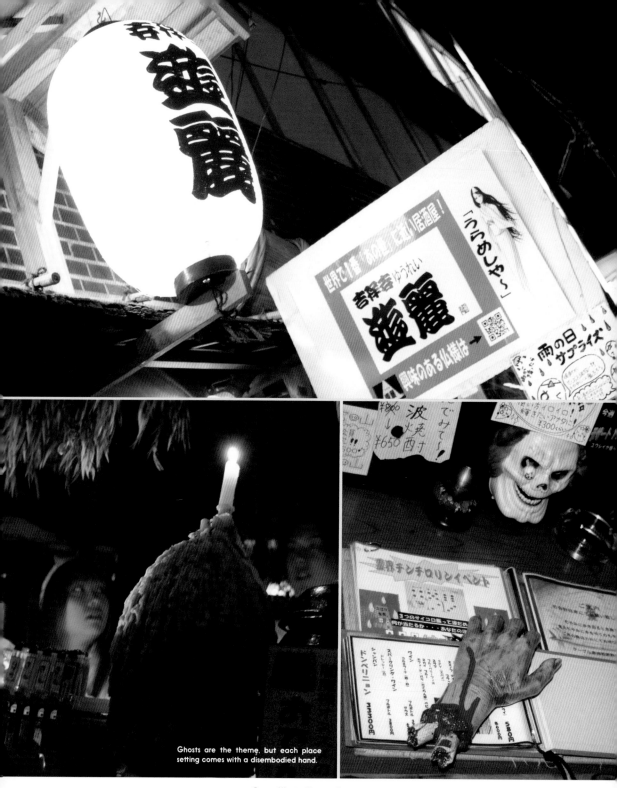

Ghosts are the theme, but each place setting comes with a disembodied hand.

Crazy, Wacky Theme Restaurants

I can't find Ghost Bar on a map, so I decide to wing it. Kichijoji is crammed with pubs and restaurants – *izakaya, shabu-shabu, sukiyaki, gyoza* – none of which are particularly terrifying. I'm ready to buy strawberry Pocky and call it a night when I hear a Scooby Doo "ooooooo" coming from an entryway. There's a decapitated female head lying in a pile of mud. I'm pretty sure this is the place.

A headless figure points me down the stairs, and my movements trigger flashing lights and a not-so-scary fan whirl. A hostess in loose white robes hands me a small, triangular cloth. She tells me to wear it on my forehead; I'm confused (I expected a bedsheet with two holes) but do it anyway. She clangs a Buddhist bell and claps twice, and all over the restaurant giant plush spiders descend and wiggle their legs.

The theme isn't so much frightening as it is random. Why are there *Scream* masks above Buddhist gravestones? Or a stuffed rooster on a lantern? Or a goofy, sunglasses-wearing monk on top of the toilet?

I decide it is my Gothic duty to spook up the joint. I pick up two of the bloody plastic hands that lie on top of the menus; I stuff one in each sleeve and stumble toward the customers: "Woooh! Wooooh!"

An old man smoking alone at the bar gives me a long stare. He ashes his cigarette, picks up the fake limb in front of him, slips it in his sleeve, and waves it in my face. "Wooooooooh!" he croaks.

I fail at haunting.

Most of my fellow ghosts are raucous businessmen who often come for a drink after work. Time to switch strategies: I remove my fake arms and approach a table of three. "Hello. How did you die?"

The young man in a striped suit doesn't blink: "*Karoshi* (from overwork)." His coworkers erupt in laughter; I'm not sure why.

Yūrei (Ghost) Bar

"Who is your favorite ghost?" I demand.

"*Kappa* (cucumber)." The men chortle and make farting noises.

Later, I look up *kappa* and learn that it can refer to a beaked river monster with a Friar Tuck haircut. They drag victims into the water and yank their intestines out through their anuses. Happily, human flatulence will drive them away.

I also learn that the servers were dressed like traditional Japanese ghosts (*yurei,* meaning "faint spirits"). Beginning in the Edo era, the dead were buried in *katabira,* or plain white kimonos sometimes inscribed with Buddhist sutras. Sometimes, an *ahitaikakushi* (triangular white cloth) was tied around the forehead. Like their Western counterparts, *yurei* tend to be pale with wild black hair and float toward their targets with outstretched arms.

All in all, there was only one aspect of Ghost Bar that struck fear into my heart – and it was the late 90s pop soundtrack that played all night long: Backstreet Boys ("Everybody"), Salt-N-Pepa with En Vogue ("Whatta Man"), All Saints ("I Know Where It's At"), Robyn ("Show Me Love"). Bubblegum flashbacks of my junior high dances, huddled in the corner, incapable of speaking to boys... now that's a terrifying ghost of the past.

Kichijoji B1, 1-8-11
Musashino, Minamicho,
Tokyo, Japan
Nearest station
Kichijoji
Open
Daily (5pm-1am)
Telephone
04-2241-0194

Chapter 2
Another Time and Place

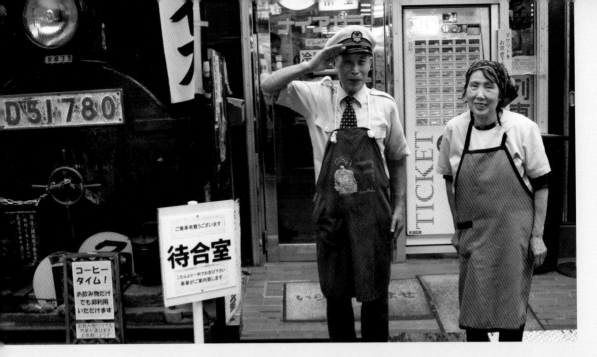

Niagara Curry (Trains)

I'm hung over, it's pouring outside and needless to say, I don't want to leave my room, let alone go shoot a train-themed curry restaurant. But there is a job to be done and the rain has turned to a drizzle by the time I reach Yutenji Station. The curry joint is down the road and resembles an anime train crash with crossing signs and flags scattered amidst a giant engine. Like at most noodle stands, I have to buy a meal ticket from the vending machine out front before entering. I press the button marked "Showa Curry."

"Tickets, please!" A hunchbacked granny in a bright orange apron gives me the most adorable lopsided smile. She's surrounded by a jumble of locomotive nostalgia; my eyes go to the illuminated station clock, brass boilerplates, steampunk gauges, faded emblems and Japan Rail seats complete with cigarette boxes. The lady hands me a weathered logbook; I add a drawing of my cat to the cheerful manga sketches.

"Choo-choo!" I expect a puff of smoke; instead, it's the steam of hot curry that shoots out from a miniature tunnel. An old-fashioned model train races along the track that encircles the restaurant, dragging my order behind it. The toy stops at my booth and backtracks after I pick up my dish. I order ice coffee and it's delivered along with teddy bears packed into a boxcar. At this point, I'm charmed through the roof.

The hearty curry isn't anything like my usual saag paneer with naan. In the late 19th century, the Japanese navy borrowed the recipe from the British (who co-opted it from India) but made it thicker and sweeter. Curry is now one of the most popular dishes in Japan; you'll find ready-made mixes at the supermarket and fast-food stands near the train stations.

"All aboard!" Another adorable smile, this time from the elder Station Master in engineer overalls. He plops a conductor's cap on my head to match his own. A salary man on a late lunch break calls him over and turns out to be a fellow train buff. Minutes later, they're absorbed in a conversation about the black-and-white photographs on the wall.

The sweet little man is Hirotoshi Naito, and he's been cosplaying (costume-playing) as Station Master since 1963. Japan Railways used to sell train parts as scrap, so Naito bought memorabilia until he ran out of room. Why didn't he join the railroad? He grew up during a time when there was little food: "I love trains, but I like curry more." Dishing out signature Showa curry at his fantasy station combines the best of both worlds.

"*Sugoi* (awesome)!" The granny and her daughter clap their hands when I tell them I'm featuring their restaurant in my book. The Station Master points out the best angles for photographs and poses with a tight salute. The women insist on walking me back to

2-1-5 Yutenji, Meguro-ku, Tokyo, Japan
Nearest station
Yutenji
Open
Daily (11am-8pm) except Mon/Thurs and the day after public holidays
Telephone
03-3710-7367
URL
www.niagara-curry.com

24

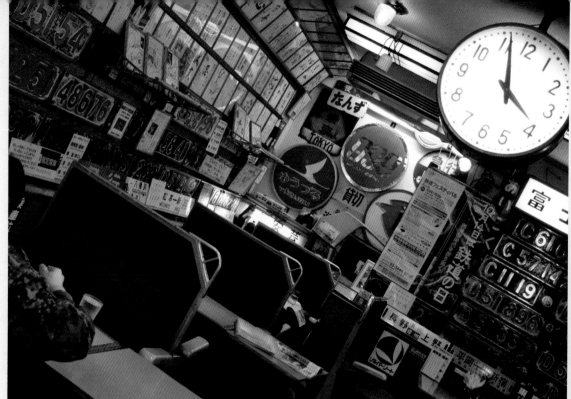

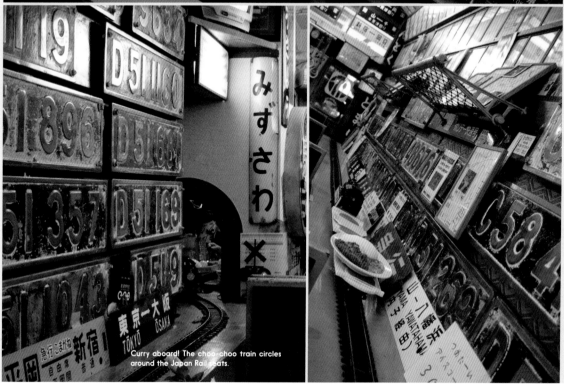

Curry aboard! The choo-choo train circles around the Japan Rail seats.

Crazy, Wacky Theme Restaurants

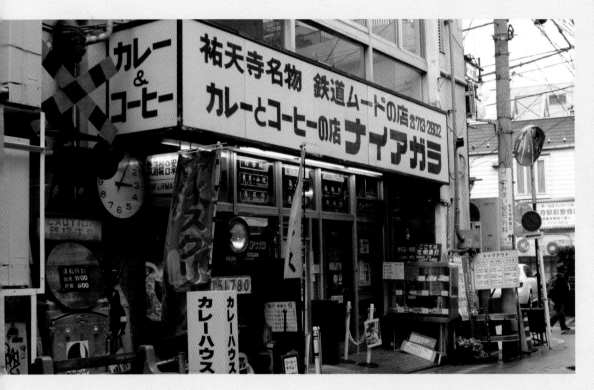

the station, stopping briefly to browse through a rack of discount jeans.

A theme restaurant visit can leave you with ringing ears and Disneyland withdrawal – but a small, family-run joint is a different story. The Saitos are mad about trains and curry, and their passion is infectious. I'll brave a thunderstorm to board the cute curry choo-choo.

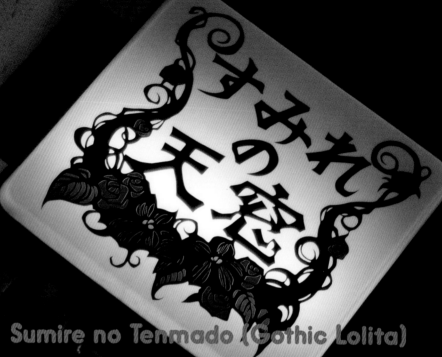

Sumire no Tenmado (Gothic Lolita)

2F Golden Gai 3-Banchi,
1-1-7 Kabukicho,
Shinjuku-ku, Tokyo, Japan
Nearest station
Shinjuku
Open
Mon-Fri (4:30-11:30pm),
Sat-Sun & holidays
(11:30am-11:30pm)
Telephone
03-3209-1204
URL
www.kokusyokusumire.net/
tenmado/index.html

On the subway ride to Shinjuku, I stand next to a Japanese girl in a frilly Victorian dress, clutching a heart-shaped purse and struggling to balance on her doll heels. Tokyo is teeming with Gothic Lolitas, as the girls who wear this morbid-meets-adorable fashion are known. For some, style equals lifestyle: the clothing is a nod to a more elegant time, a bygone era when ladies wore corsets and danced graceful minuets.

Somnium in Tenebris, a music organizer from Greece, often leaves passionate comments on my blog, lamenting the commercialization of Lolita fashion; denouncing those who buy lace headdresses and then chuck them for the next new trend.

It makes sense to meet her at a Goth Loli themed café, Sumire no Tenmado. The owners are Sachi and Yuka, two living embodiments of Victorian dolls. The posters on the stairwell reveal that by night, the young women are a classical music duo called Kokusyoku Sumire.

As on most days, violinist Sachi welcomes us from behind the counter with a heart-melting smile. She's a Gothic Lolita through and throughout: white lace gown, Alice in Wonderland jewelry, waist-length hair with bangs. This isn't her stage presence; this is her life.

Kitchen aside, the café could pass for a 19th century girl's bedroom. The trinkets strewn about look like they'd come alive at night: a grinning pink plush octopus, twin Blythe dolls, sleepy teddy bears, a brass rotary phone. A signature and chalk drawing of Jack Skellington overlook the room, left by none other than director Tim Burton.

We drink high tea with rosebuds and polish off two slices of her homemade pumpkin cake. "It must have been a secret magical recipe," sighs Somnium as she savors the last gooey bite.

Beyond the lace-curtained windows, businessmen stumble from the adjacent seedy dives. But Somnium and I are oblivious, blissfully submerged in a Gothic Lolita world of dreams.

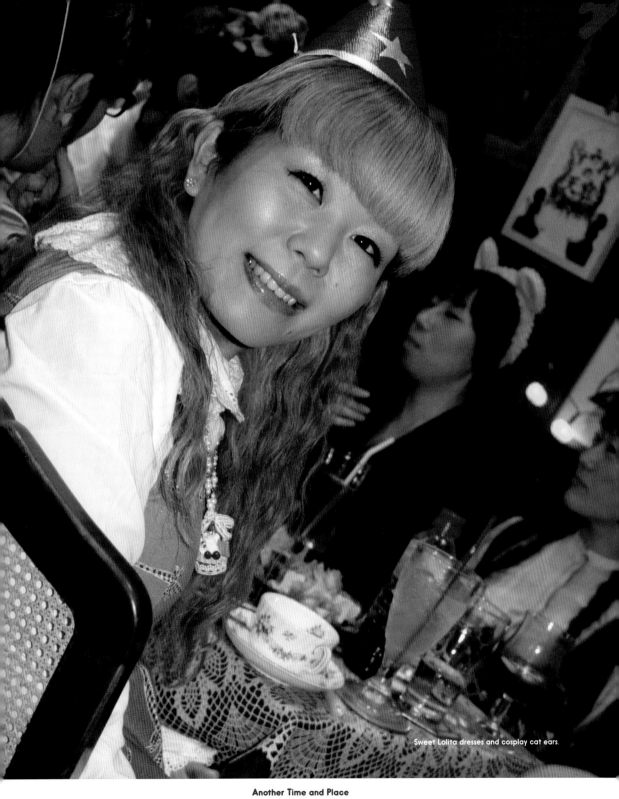

Sweet Lolita dresses and cosplay cat ears.

Another Time and Place

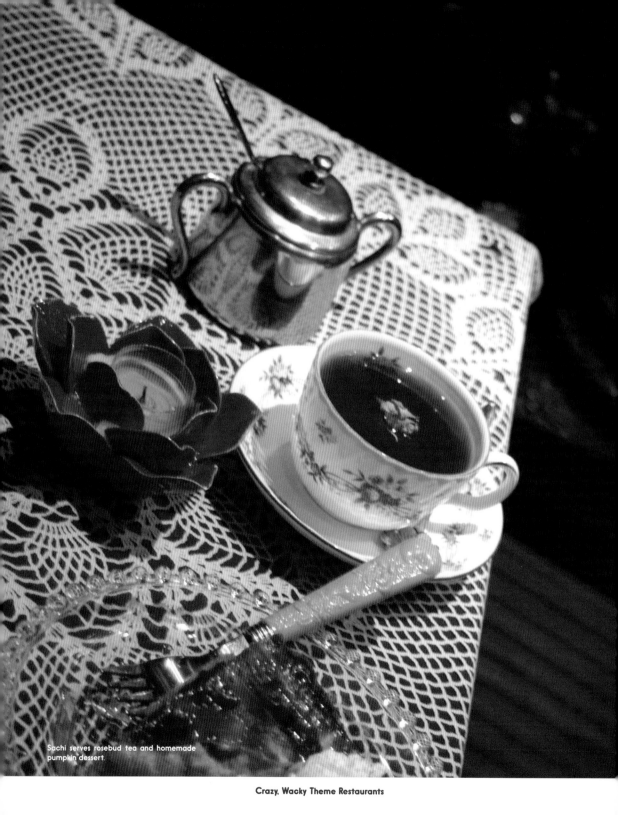

Sachi serves rosebud tea and homemade
pumpkin dessert.

Crazy, Wacky Theme Restaurants

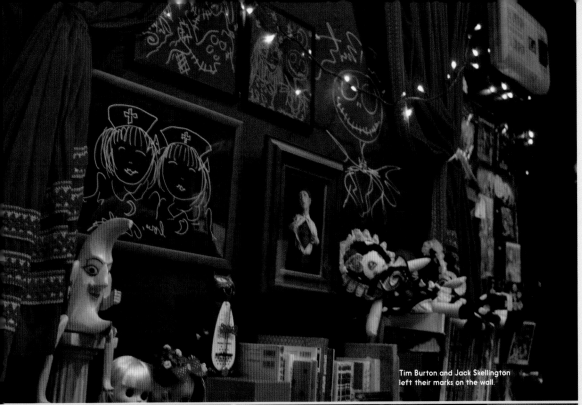

Tim Burton and Jack Skellington left their marks on the wall.

Another Time and Place

Seiryumon (Little Hong Kong)

**Palette Town Venus Fort
1040, 1 Oume,
Eto-ku, Tokyo, Japan
Nearest station**
Oume, Tokyo Teleport,
or Odaiba Kaihin Park
Open
Mon-Thurs & Sun
(11am-11pm),
Fri-Sat (11am-5pm)
Telephone
03-3599-2255
URL
www.gnavi.co.jp/gn/en/
g062711h.htm

Dear Auntie Wanda,

I am a disappointment to you, I know. I dress funny. My Cantonese is atrocious. We don't agree on a lot of things, especially when it comes to the subject of boys. You think I should be close to getting married; I don't see that happening for some time. And you shake your head at the boys I associate with. "They look like girl" you frown. "Pants too tight! Hair all over face!"

As for weddings - you didn't quite "get" my vision. In any case, I believe in compromises, and I think I've figured out a way to combine Tokyo theme... with traditional Chinese. Hear me out, please.

There is an artificial island in Tokyo Bay called Odaiba. It's easy to reach by monorail and has plenty of attractions, clothing stores, even a cat petting zoo (page 86). But nothing beats the sixth and seventh floors of Decks shopping mall, which have been transformed into Little Hong Kong.

Believe me, it's better than the real deal. In-your-face store signs? Cardboard cut-outs of Jackie Chan? Hidden speakers that emit street chatter, Canto-pop, the roar of jets? Yes to all, in addition to eight Chinese restaurants and zero chance of catching the bird flu.

We can start here with a welcome reception and then walk across the bridge to Venus Fort. This mall is supposed to look like 17th century Venice but basi-

cally screams Caesar's Palace, what with the half-naked statues and painted sky that sets every two hours. The chapel rents out traditional Chinese garments, so I'll be loaded down with a tasseled headdress while the groom has a long braid trailing down the back of his cap. Our wedding will look exactly like grandma's – only that we're standing in front of a mock-façade of the Pantheon.

We'll have our banquet ten paces away at Seiryumon. The restaurant mimics an old-time Taiwanese theater, from the box office stalls to the scraps of movie poster on concrete walls. My new husband and I will sit in a raised booth shadowed by gold dragon heads, and our twelve-course feast will be interrupted only by a contortionist stage show.

It's too bad the Shinjuku location closed down because the toilets were out of this world. In the ladies' room, a fake wall opened and out popped a crazy man carrying a roll of toilet paper. The men's urinal was a plump, six-handed idol clutching a pair of red lips. Suddenly, the mouth sang opera and the bowl swayed, the idol's head rotated, and the camera in one of his hands flashed. Oh, Uncle Jeffrey would pee all over himself!

So what do you say? I hope it's *Seiryumon* (Blue Dragon Gate) – because that's the secret password to enter the restaurant.

Your dutiful niece,
La Carmina

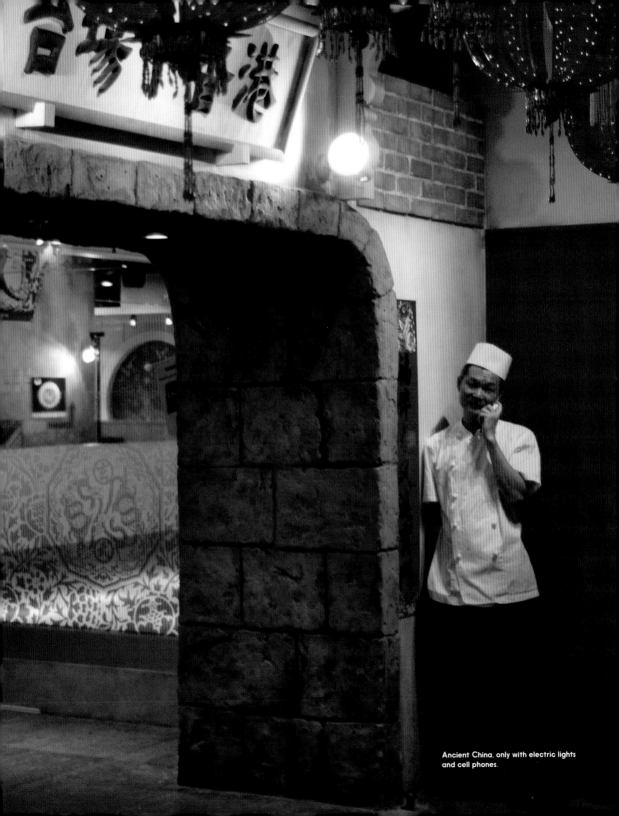

Ancient China, only with electric lights and cell phones.

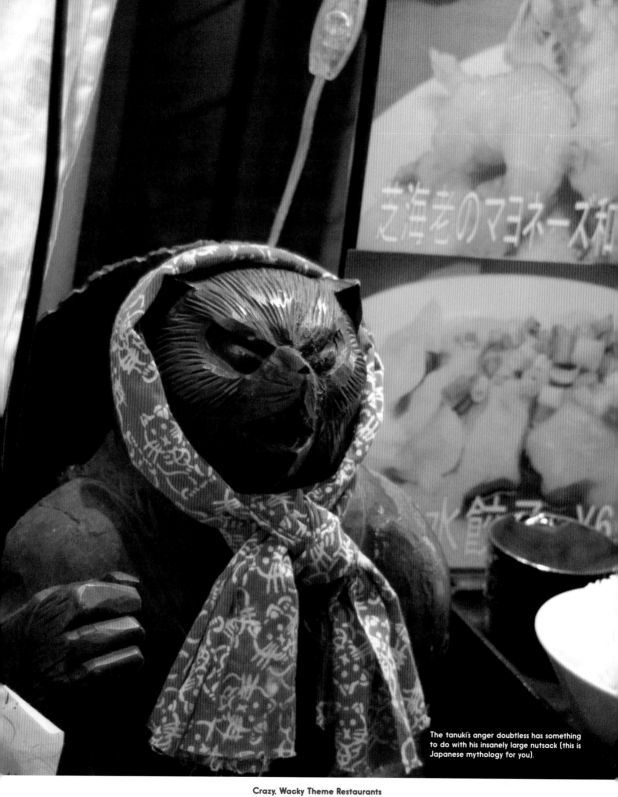

The tanuki's anger doubtless has something to do with his insanely large nutsack (this is Japanese mythology for you).

Crazy, Wacky Theme Restaurants

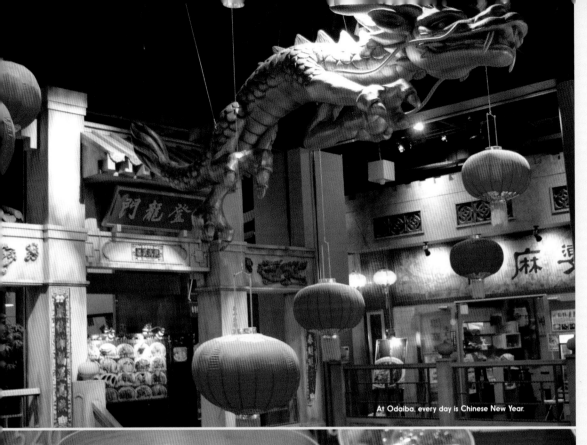

At Odaiba, every day is Chinese New Year.

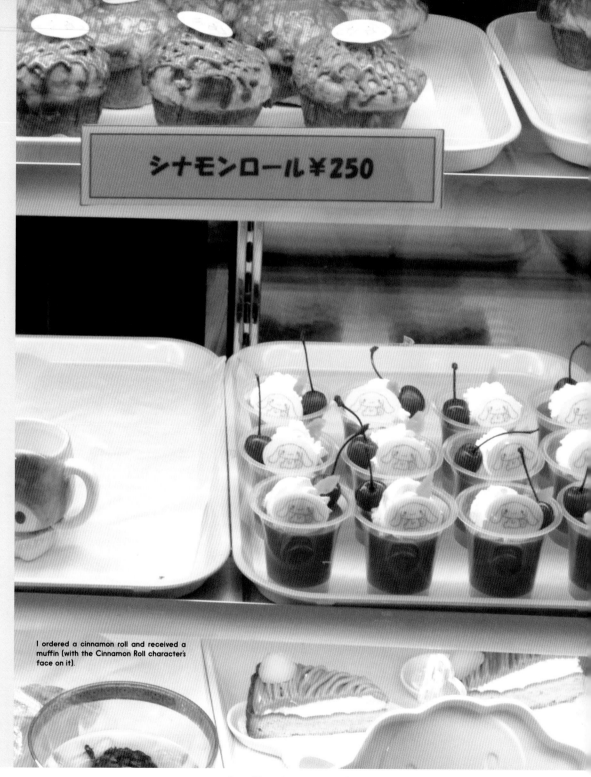

シナモンロール￥250

34

I ordered a cinnamon roll and received a muffin (with the Cinnamon Roll character's face on it).

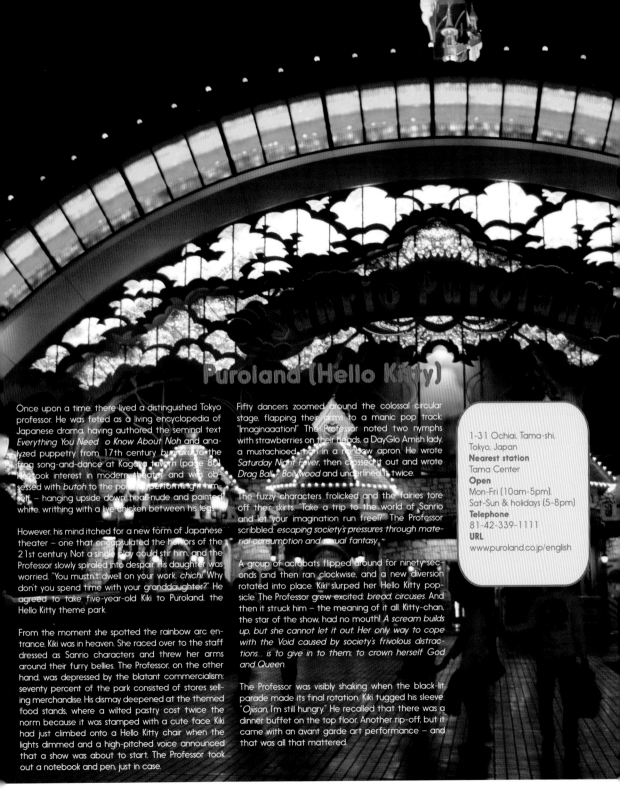

Puroland (Hello Kitty)

Once upon a time, there lived a distinguished Tokyo professor. He was feted as a living encyclopedia of Japanese drama, having authored the seminal text *Everything You Need o Know About Noh* and analyzed puppetry from 17th century *bunraku* to the frog song-and-dance at Kagaya tavern (page 80). He took interest in modern theater and was obsessed with *butoh* to the point of performing it himself – hanging upside down, near-nude and painted white, writhing with a live chicken between his legs.

However, his mind itched for a new form of Japanese theater – one that encapsulated the horrors of the 21st century. Not a single play could stir him, and the Professor slowly spiraled into despair. His daughter was worried. "You mustn't dwell on your work, *chichi*. Why don't you spend time with your granddaughter?" He agreed to take five-year-old Kiki to Puroland, the Hello Kitty theme park.

From the moment she spotted the rainbow arc entrance, Kiki was in heaven. She raced over to the staff dressed as Sanrio characters and threw her arms around their furry bellies. The Professor, on the other hand, was depressed by the blatant commercialism: seventy percent of the park consisted of stores selling merchandise. His dismay deepened at the themed food stands, where a wilted pastry cost twice the norm because it was stamped with a cute face. Kiki had just climbed onto a Hello Kitty chair when the lights dimmed and a high-pitched voice announced that a show was about to start. The Professor took out a notebook and pen, just in case.

Fifty dancers zoomed around the colossal circular stage, flapping their arms to a manic pop track: "Imaginaaation!" The Professor noted two nymphs with strawberries on their heads, a DayGlo Amish lady, a mustachioed man in a rainbow apron. He wrote *Saturday Night Fever*, then crossed it out and wrote *Drag Ball : Bollywood* and underlined it twice.

The fuzzy characters frolicked and the fairies tore off their skirts. "Take a trip to the world of Sanrio and let your imagination run free!" The Professor scribbled: *escaping society's pressures through material-consumption and sexual fantasy.*

A group of acrobats flipped around for ninety seconds and then ran clockwise, and a new diversion rotated into place. Kiki slurped her Hello Kitty popsicle. The Professor grew excited: *bread, circuses.* And then it struck him – the meaning of it all. Kitty-chan, the star of the show, had no mouth! *A scream builds up, but she cannot let it out. Her only way to cope with the Void caused by society's frivolous distractions... is to give in to them; to crown herself God and Queen.*

The Professor was visibly shaking when the black-lit parade made its final rotation. Kiki tugged his sleeve: "*Ojiisan*, I'm still hungry." He recalled that there was a dinner buffet on the top floor. Another rip-off, but it came with an avant garde art performance – and that was all that mattered.

1-31 Ochiai, Tama-shi, Tokyo, Japan
Nearest station
Tama Center
Open
Mon-Fri (10am-5pm),
Sat-Sun & holidays (5-8pm)
Telephone
81-42-339-1111
URL
www.puroland.co.jp/english

Another Time and Place

This time, a dog character named Cinnamon Roll flew down from the sky and was joined by three friends. All of them were horribly deformed with bulging bellies and nubs for arms. The Professor scratched away with his pen: *The legacy of Hiroshima – agony of the human genome!*

Scantily-clad dancers introduced a curtained doorway and the dog explained, "The gates lead to another universe created by your imagination." His friend Mocha wished to be a clothing designer, and out came models singing "Fashion, fashion, fashion!" Espresso wanted to be in showbiz; he got a cancan routine and a screen flashing "I'm So Cool." *The delusion of glamour; the equation of fame with self-fulfillment ...* Cappucino emerged with hot dogs that raised the roof and chanted "Yo, yo!" *Buttressing our fragile egos with junk food and gangsta rap...* Suddenly, a life-size burger attacked and tried to eat him with a Pacman-mouth: "Booga, booga, booga!" *That which we consume...consumes us.*

The Professor was silent the entire trip home. "Good lord!" sputtered his daughter upon seeing his face. "Was the theme park that awful?"

Kiki beamed toothily. "There was happy music and Keroppi and My Melody danced funny and I got to hug them!"

The Professor kissed his granddaughter goodnight and shut himself in his study. He opened a new word processing file and put his fingers on the keyboard. *Kitty's Silent Scream. The religion of Commerce so eagerly embraced by the Japanese has spawned a Godzilla – in a form known as the Sanrio Musical – to mirror the monsters that we ourselves have created...*

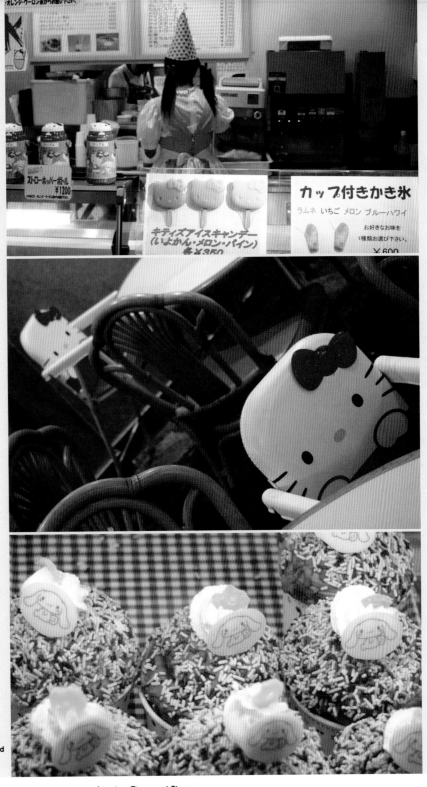

You know you're in Japan when the food and highchairs look like Hello Kitty.

Chapter 3
Storybook

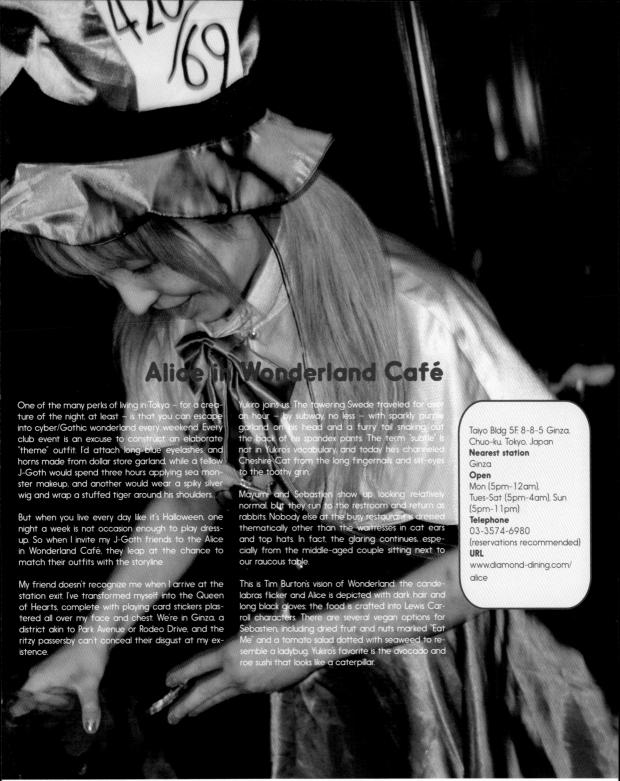

Alice in Wonderland Café

One of the many perks of living in Tokyo – for a creature of the night, at least – is that you can escape into cyber/Gothic wonderland every weekend. Every club event is an excuse to construct an elaborate "theme" outfit. I'd attach long blue eyelashes and horns made from dollar store garland, while a fellow J-Goth would spend three hours applying sea monster makeup, and another would wear a spiky silver wig and wrap a stuffed tiger around his shoulders...

But when you live every day like it's Halloween, one night a week is not occasion enough to play dress-up. So when I invite my J-Goth friends to the Alice in Wonderland Café, they leap at the chance to match their outfits with the storyline.

My friend doesn't recognize me when I arrive at the station exit. I've transformed myself into the Queen of Hearts, complete with playing card stickers plastered all over my face and chest. We're in Ginza, a district akin to Park Avenue or Rodeo Drive, and the ritzy passersby can't conceal their disgust at my existence.

Yukiro joins us. The towering Swede traveled for over an hour – by subway, no less – with sparkly purple garland on his head and a furry tail snaking out the back of his spandex pants. The term "subtle" is not in Yukiro's vocabulary, and today he's channeled Cheshire Cat from the long fingernails and slit-eyes to the toothy grin.

Mayumi and Sebastien show up looking relatively normal, but they run to the restroom and return as rabbits. Nobody else at the busy restaurant is dressed thematically other than the waitresses in cat ears and top hats. In fact, the glaring continues, especially from the middle-aged couple sitting next to our raucous table.

This is Tim Burton's vision of Wonderland: the candelabras flicker and Alice is depicted with dark hair and long black gloves; the food is crafted into Lewis Carroll characters. There are several vegan options for Sebastien, including dried fruit and nuts marked "Eat Me" and a tomato salad dotted with seaweed to resemble a ladybug. Yukiro's favorite is the avocado and roe sushi that looks like a caterpillar.

Taiyo Bldg 5F, 8-8-5 Ginza, Chuo-ku, Tokyo, Japan
Nearest station
Ginza
Open
Mon (5pm-12am),
Tues-Sat (5pm-4am), Sun
(5pm-11pm)
Telephone
03-3574-6980
(reservations recommended)
URL
www.diamond-dining.com/
alice

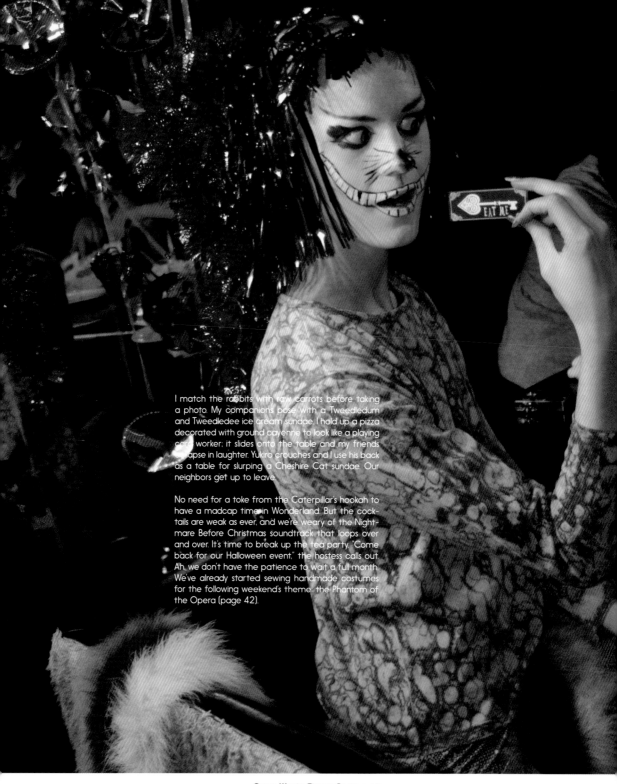

I match the rabbits with raw carrots before taking a photo. My companions pose with a Tweedledum and Tweedledee ice cream sundae. I hold up a pizza decorated with ground cayenne to look like a playing card worker; it slides onto the table and my friends collapse in laughter. Yukiro crouches and I use his back as a table for slurping a Cheshire Cat sundae. Our neighbors get up to leave.

No need for a toke from the Caterpillar's hookah to have a madcap time in Wonderland. But the cocktails are weak as ever, and we're weary of the Nightmare Before Christmas soundtrack that loops over and over. It's time to break up the tea party. "Come back for our Halloween event," the hostess calls out. Ah, we don't have the patience to wait a full month. We've already started sewing handmade costumes for the following weekend's theme: the Phantom of the Opera (page 42).

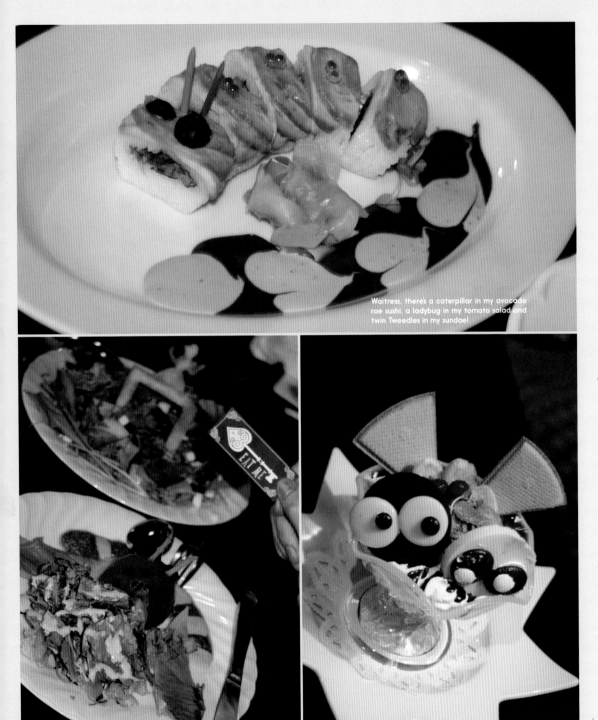

Waitress, there's a caterpillar in my avocado roe sushi, a ladybug in my tomato salad and twin Tweedles in my sundae!

41

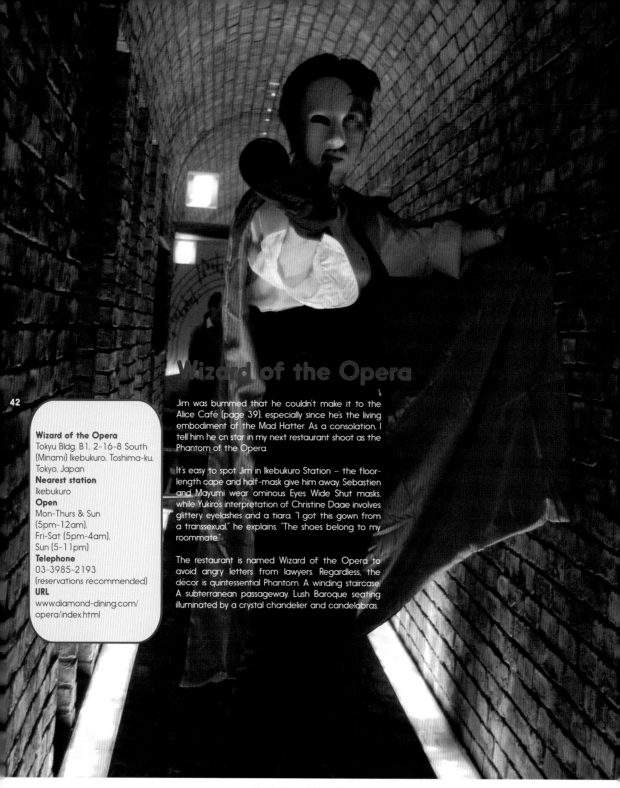

Wizard of the Opera

Wizard of the Opera
Tokyu Bldg. B1, 2-16-8 South
(Minami) Ikebukuro, Toshima-ku,
Tokyo, Japan
Nearest station
Ikebukuro
Open
Mon-Thurs & Sun
(5pm-12am),
Fri-Sat (5pm-4am),
Sun (5-11pm)
Telephone
03-3985-2193
(reservations recommended)
URL
www.diamond-dining.com/
opera/index.html

Jim was bummed that he couldn't make it to the Alice Café (page 39), especially since he's the living embodiment of the Mad Hatter. As a consolation, I tell him he cn star in my next restaurant shoot as the Phantom of the Opera.

It's easy to spot Jim in Ikebukuro Station – the floor-length cape and half-mask give him away. Sebastien and Mayumi wear ominous Eyes Wide Shut masks, while Yukiro's interpretation of Christine Daae involves glittery eyelashes and a tiara. "I got this gown from a transsexual," he explains. "The shoes belong to my roommate."

The restaurant is named Wizard of the Opera to avoid angry letters from lawyers. Regardless, the décor is quintessential Phantom. A winding staircase. A subterranean passageway. Lush Baroque seating illuminated by a crystal chandelier and candelabras.

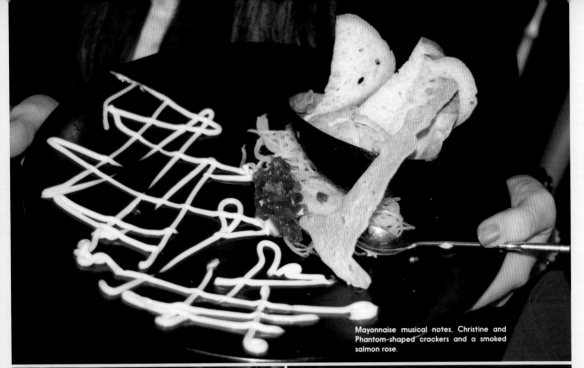

Mayonnaise musical notes, Christine and Phantom-shaped crackers and a smoked salmon rose.

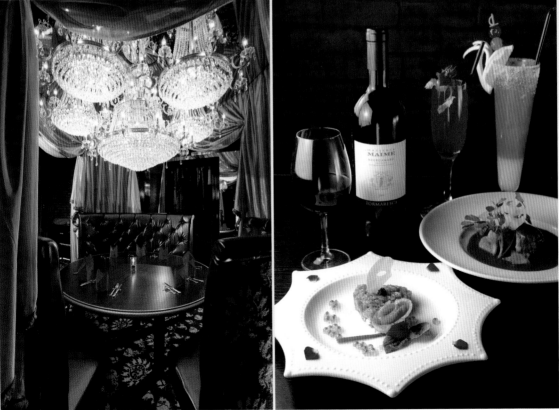

Yousei no Tani (Valley of the Fairies)

Sankei Bldg, 38 B1F,
1-6-7, Kabukicho,
Shinjuku-ku, Tokyo, Japan
Nearest station
Shinjuku
Open
Sun-Thurs (5pm-12am),
Fri-Sat (5pm-4am)
Telephone
03-5155-8515
URL
www.youseinotani.com

"Tell me a fairytale," urges my little cousin Ashley.

"I haven't read the Brothers Grimm in a while," I confess, "but I can tell you about the Valley of the Fairies.

"The entrance to this theme restaurant – I mean, enchanted world – is concealed by gaudy host clubs and game centers. Your poor cousin has to walk around Kabuki-cho several times to find it. She cautiously descends a steep staircase lined with pink drapes and Victorian picture frames. The gilded arch at the bottom opens, and your cousin is greeted by beautiful winged fairies."

"Tiny ones?" interjects Ashley.

"No... life-size Japanese ones. They sweep her into one of the fairy pods: a beehive-shaped tent covered with shimmering fabric and trailing roses and Christmas lights.

"Before long, your cousin sneaks out and climbs the spiral staircase. Each room is colored in different pastels, and the beams are so low that she hits her head several times. The unrelenting fairy music – MIDI versions of Pachabel's Canon and Music Box Dancer – adds to her throbbing headache."

"And do the fairies feed you nectar?"

"Well, they basically serve Italian food with multi-colored cocktails. The names are sort of fun. I had a Leprechaun Cookie Shake and Elf Fruit Tea."

Ashley looks disappointed. "Do they at least enchant you with fairy dust?"

"Not really... they just bring the check."

Wednesday is "Fairy Day"; Thursday is "Beer Half Price" day.

Crazy, Wacky Theme Restaurants

Like college students, fairies apparently decorate with draped fabrics and holiday lights.

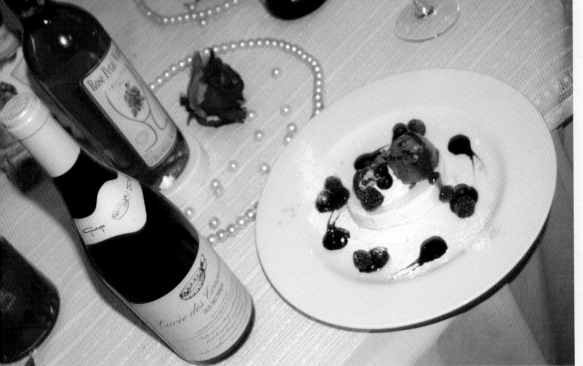

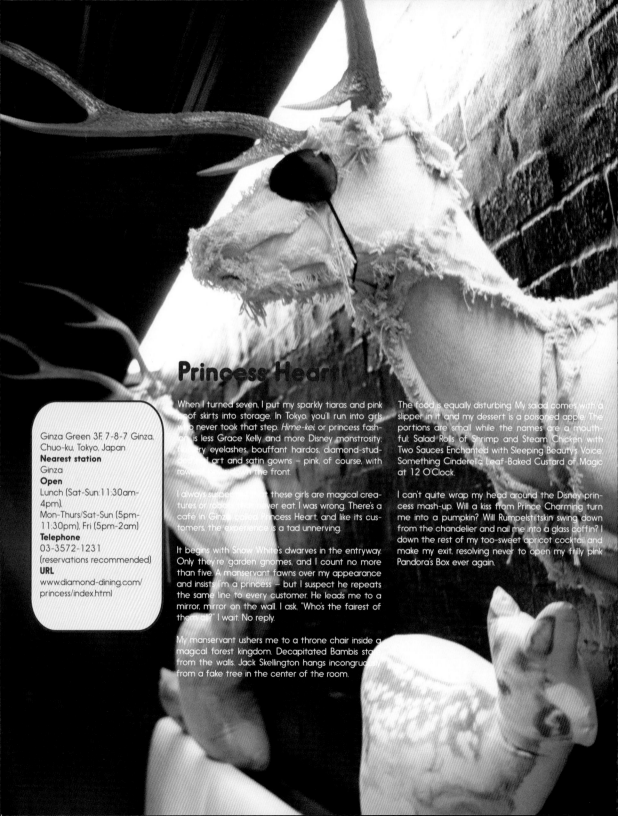

Princess Heart

Ginza Green 3F, 7-8-7 Ginza,
Chuo-ku, Tokyo, Japan
Nearest station
Ginza
Open
Lunch (Sat-Sun:11:30am-
4pm),
Mon-Thurs/Sat-Sun (5pm-
11:30pm), Fri (5pm-2am)
Telephone
03-3572-1231
(reservations recommended)
URL
www.diamond-dining.com/
princess/index.html

When I turned seven, I put my sparkly tiaras and pink poof skirts into storage. In Tokyo, you'll run into girls who never took that step. *Hime-kei*, or princess fashion, is less Grace Kelly and more Disney monstrosity: feathery eyelashes, bouffant hairdos, diamond-studded nail art and satin gowns – pink, of course, with rows of bows down the front.

I always suspected that these girls are magical creatures or robots that never eat. I was wrong. There's a café in Ginza called Princess Heart, and like its customers, the experience is a tad unnerving.

It begins with Snow White's dwarves in the entryway. Only they're garden gnomes, and I count no more than five. A manservant fawns over my appearance and insists I'm a princess – but I suspect he repeats the same line to every customer. He leads me to a mirror, mirror on the wall. I ask, "Who's the fairest of them all?" I wait. No reply.

My manservant ushers me to a throne chair inside a magical forest kingdom. Decapitated Bambis stare from the walls. Jack Skellington hangs incongruously from a fake tree in the center of the room.

The food is equally disturbing. My salad comes with a slipper in it and my dessert is a poisoned apple. The portions are small while the names are a mouthful: Salad Rolls of Shrimp and Steam Chicken with Two Sauces Enchanted with Sleeping Beauty's Voice, Something Cinderella Leaf-Baked Custard of Magic at 12 O'Clock.

I can't quite wrap my head around the Disney princess mash-up. Will a kiss from Prince Charming turn me into a pumpkin? Will Rumpelstiltskin swing down from the chandelier and nail me into a glass coffin? I down the rest of my too-sweet apricot cocktail and make my exit, resolving never to open my frilly pink Pandora's Box ever again.

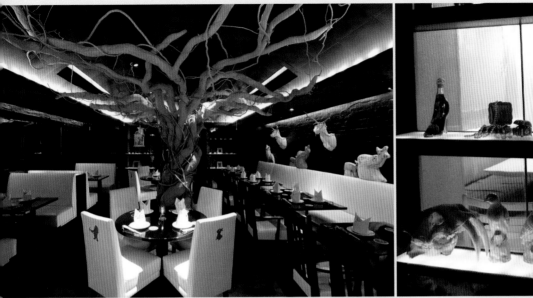

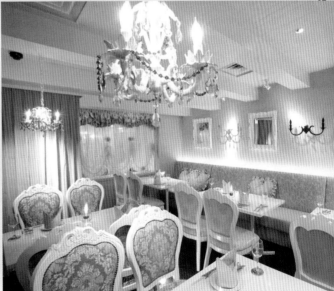

A vial of poison for Snow White, a glass slipper for Cinderella and a carb coma for Sleeping Beauty.

Chapter 4
The Gods Must Be Angry

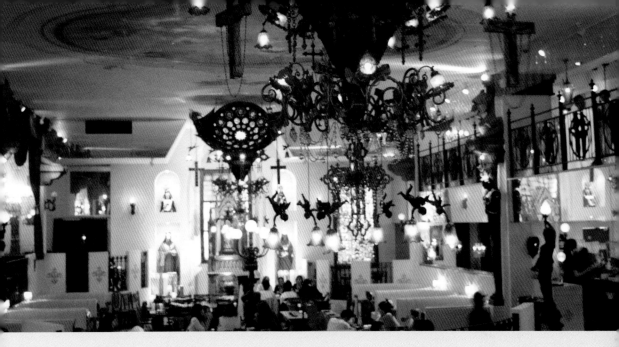

Christon Café

A few years ago, I had just entered a cathedral somewhere in Italy – the memories are fuzzy – when I was bum-rushed by a staffer and pushed back onto the portico. His hands were generally waving at my stomach. Ah, *comprendo*: I was wearing a tank top with an asymmetrical hem that diagonally bisected my bellybutton, leaving a triangle of flesh exposed.

Apparently, I was too sexy for this church.

So when Sebastien wasn't allowed into Christon Café – the popular Jesus-themed eatery with eight locations in Japan – I sympathized. "I was wearing a battle-damaged gas mask and vintage Nintendo Power Glove, which I thought was a really original accessory," he sighed. "Alas, it turned out that the people at the entrance did not appreciate what I was wearing and decided not to let me in – even though I was on the guest list and had friends inside!"

Apparently, Sebastien wasn't sexy enough for the Christon Fetish Ball.

You read that right: for the second year in a row, the Tokyo Kink Society held its celebration of all things bound and whipped at a Catholic-themed café. The organizers brought in pole dancers and dungeon masters who strung up suspension cages next to statues of the Virgin Mary.

"The place was packed. We couldn't even dance," said Jim, who had smeared on Joker makeup and cross-dressed in a barely-there maid outfit. He breaks down the crowd into four groups: sexy, drag, Goth-horror, "and scary old men in PVC panties that I could do without looking at."

Jim's rant prepared me for Tokyo Decadance at Christon Shinjuku, an all-night Halloween party with cyber DJs and fetish performers. I put on towering red knee boots, a leather lace-up corset, heavy black eyeshadow, and garlands of fake roses. I was not only admitted – I got the discount rate.

And I witnessed scenes that would make the Marquis de Sade scratch his head. Two dominatrixes lurked around the altar – a bona fide European relic – dripping hot candle wax onto a hooded slave's back. A girl with feathered eyelashes used an angel statue as a makeshift pole for dancing. Near the entrance, a man in leopard-print bikini briefs had passed out on a pew.

Yet it didn't come across as blasphemy – partly because of the overwhelming kitsch, and partly because the club kids didn't view it as such. Christianity wasn't allowed to propagate in Japan until the late 19th century, and today, only a thimbleful of the population identifies with the religion. Crosses and chalices aren't loaded with meaning as they are in the West. And so, a cathedral becomes a sweet place to throw a party.

The staff is inclined to agree: most take part in the Goth/Lolita scene and work at Christon because it jives with their aesthetic. When I visited the Shibuya

(Eight locations in Japan)

Shibuya
New Mainstay Bldg. B1,
Dogenzaka 2-10-7,
Shibuya-ku, Tokyo, Japan
Nearest station
Shibuya
Telephone
03-5728-2225

Shinjuku
Oriental Wave Bldg. 8F,
5-17-13 Shinjuku,
Shinjuku-ku, Tokyo, Japan
Nearest station
Shinjuku
Telephone
03-5287-2426

Open
Mon-Thurs, Sun & holidays
(5pm-11pm),
Fri-Sat (5pm-4am)
URL
http://r.gnavi.co.jp/g465409

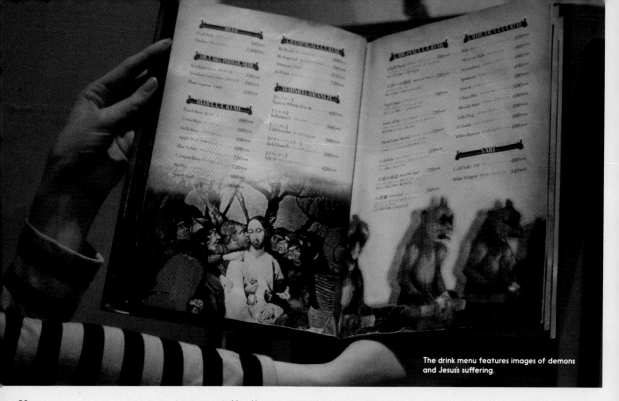

The drink menu features images of demons and Jesus's suffering.

location with Man Heaven, the room was teeming with other young Gothic couples. Christon makes sense as a date spot; whenever there's a lag in the conversation, you can always turn it back to the Biblically-themed entrees: Satan's Seafood Rice, Tower of Babel Salad. Or the cocktails, devilishly named Jekyll and Hyde, Joan of Arc, Mont St. Michel. Or the dessert menu, laden with misspellings: Crape of Yogurt Mousse, Strawberry Flesh Cream Cake with Shaerbet. And how about Satan, spreading his six-foot wings above the confession booths?

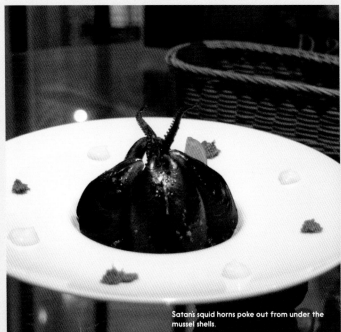

Satan's squid horns poke out from under the mussel shells.

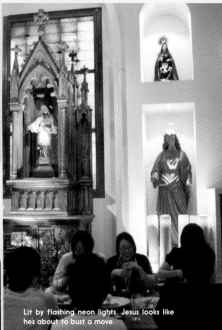

Lit by flashing neon lights, Jesus looks like he's about to bust a move.

The Gods Must Be Angry

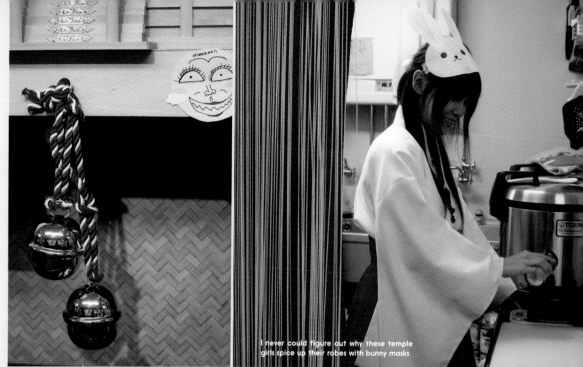

I never could figure out why these temple girls spice up their robes with bunny masks.

54

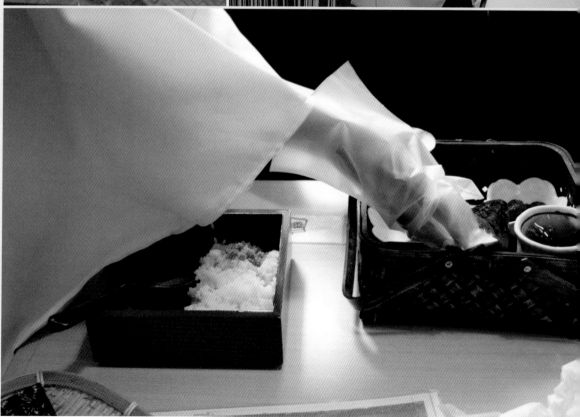

Crazy, Wacky Theme Restaurants

Miko-san Café (Shinto Temple Girls)

At least a dozen people have asked me if, while in Tokyo, I visited any temples. The answer is no. Well, maybe. Judge for yourself whether Miko-san Café makes the cut.

Mikos are shrine maidens that assist with Shinto ceremonies. Traditionally virgins, today's attendants are generally unmarried and chaste. The temples where they serve are almost always in the thick of nature, where *kami* (spirits) are most concentrated.

So how authentic is an Akihabara café where the waitresses dress like *mikos*?

Exhibit A: the *torii*. Like at most Shinto shrines, the entrance has an orange gate with two horizontal rails. Only this one is less than six-feet high — low enough for me to bump my head.

Exhibit B: the *kamidana*. Two nerdish young men bow before the miniature shrine. But they neglect to wash their hands beforehand, and one of them says his prayer out loud: "I wish I were better at video games."

Exhibit C: the *miko*. The girls wear traditional kimono shirts and *tabi* (soft white indoor shoes), and hold *gohei* (ritual wands with zigzag paper strips). Their *hakama* (long red skirts), however, aren't much longer than your average cut-off shorts.

And that's the extent of the Shinto. Everything else about Miko-san is pure maid café. My server rolls salmon and plum *onigiri* (rice balls) and offers them to me in a basket with a shy smile. A snaggle-toothed miko and I play the Crocodile Dentist game, and when the jaws snap on her finger, she dissolves into giggles.

I venture into the downstairs performance room, where a waitress in a Sweet Lolita dress does her best to lip-synch to a frantic J-pop song. She salutes and lifts one leg in the air, cupping her chin with both hands. Somehow, I don't think this type of behavior takes place at a Shinto purification ritual.

When I make my exit, the *mikos* clap their hands and bow while reciting a prayer of well wishes. I wouldn't say I left feeling spiritually cleansed – but charmed? Happy? Well-fed? Perhaps I didn't lose out by choosing religion-themed cafés over places of worship.

Suehiro Bldg. 7F/8F, 3-15-6 Sotokanda, Chiyoda-ku, Tokyo, Japan
Nearest station
Akihabara or Suehirocho
Open
Daily (11:30am-10pm)
Telephone
01-2084-3535
URL
www.mikosancafe.com

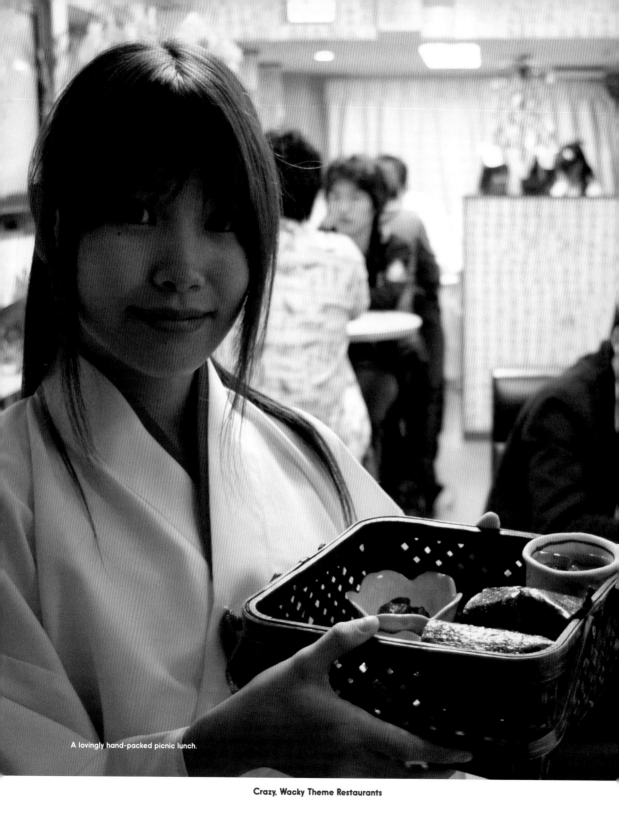

A lovingly hand-packed picnic lunch.

Crazy, Wacky Theme Restaurants

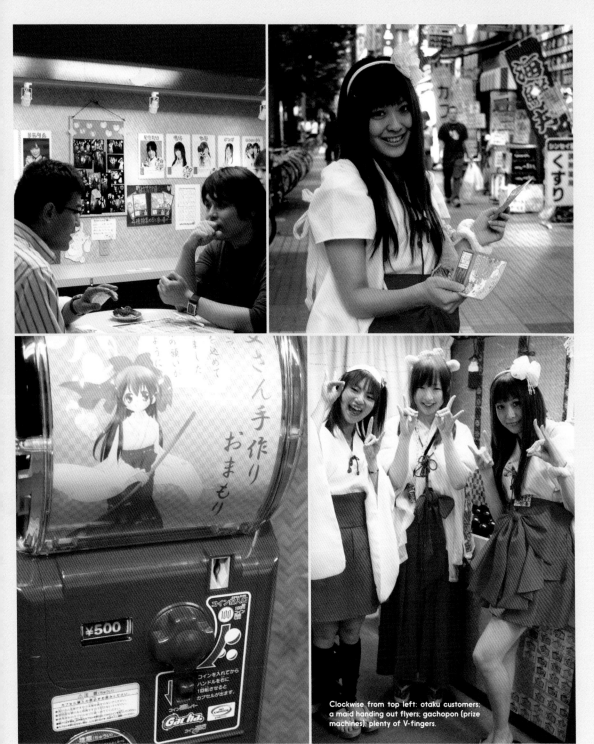

Clockwise from top left: otaku customers; a maid handing out flyers; gachopon (prize machines); plenty of V-fingers.

The Gods Must Be Angry

Chapter 5
Maids and Cosplay

A Place Called Akihabara
(Maid Cafés)

My first foray into the world of maid cafés was – as the internet meme goes – an epic fail. I've always shied away from Akihabara, aka Electric Town, dork-culture hub of Tokyo and home to *otaku*, or obsessive fans of manga, anime, video games, computers and pop idols in tiny skirts. Other than a brief love affair with Mario Kart, none of these have ever appealed to me. But I was fascinated by Akihabara's maid cafés, where customers are supposedly treated like royalty. Is it true that the maids fall to their knees and address you as Master? And offer spoon-feedings and ear-cleanings? I packed my camera and went to investigate.

I step out of the station and into a blipping, blinking, blaring pinball machine. The main road is lined with flat-topped towers, each plastered with cartoon girls busting out of tiny outfits. Outside an electronics giant, employees in red tracksuits yell into megaphones over the strains of a battle march. Inside the five-story Club Sega, two businessmen hunch over arcade screens next to UFO-catchers stocked with sexy figurines. Akiba is dominated by men – and yes, I count a few stereotypical *otaku* in untucked plaid shirts and too-tight backpacks.

I spot a French maid handing out flyers to passersby. When I raise my camera, she hastily shields her face. I readjust my stance; this time, she turns around and storms away. The same happens when I sneak up on a girl in a heart-shaped apron. The frustration mounts when I follow a sign with pretty *meidos* on it – and end up in a costume store. Another banner

leads to a massage parlor, where I glimpse a maid rubbing a man's feet. By the time I reach a bona fide café, I am so discombobulated that I lose the nerve to walk in.

Epic fail.

I learned my lesson. The next time around, I mapped out the cafés and made arrangements to take photos. A month later, I had visited a dozen of them, no sweat. The novelty wore off surprisingly fast. Maid cafés aren't as creepy as the media can make them out to be. In fact, I'd say my local Dunkin Donuts is twice as frightening as a maid massage parlor. Still, what goes on in these nerdish centers? Who are the maids? And why do the customers cry mow-eh, mow-eh?

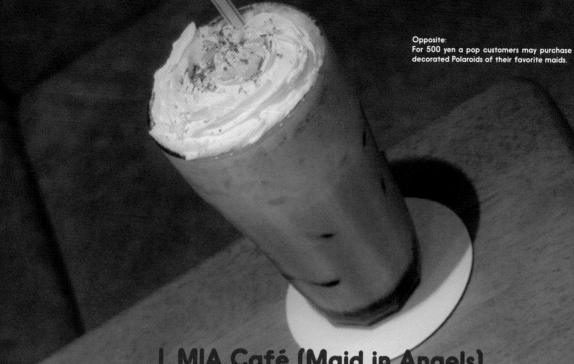

I. MIA Café (Maid in Angels)

The café overlooks the street, loft-like. Beige walls and sofa seating. Could be mistaken for a normal café, if not for the bits and pieces of *meido*. Figurine lighters. Posters and Polaroids on the wall. A looping DVD of the staff in the backseat of a van, bopping each other with a yellow plastic hammer. The server wears a not-quite-authentic maid outfit, complete with white lace headdress. She curtseys hello.

What is your name?
"Ten. It means Heaven or Sky."

May I ask your real name?
"We don't give that out. Each maid uses a nickname that reflects something she likes – so one of the girls is called Soba, and another is Kinako (soybean powder)."

How about your age?
"It's also a secret! Most of us are aged 18-20. A 15-year-old just joined us..."

She's still in high school, then.
"Yes, many of us are students and work here part-time."

How long have you been at MIA Café?
"Two and a half years. I really like it here and I see myself staying, even though things have changed a lot..."

Like what?
"When MIA opened in 2004, we were one of only three maid cafés. Now, Akiba is full of them and

there is every type of spin-off: little sister, mother, butler, schoolboy..."

What is your typical customer like?
"During lunchtime, we mostly see businessmen. Of course MIA is popular with *akiba-kei* (young men who spend their leisure time in Akihabara), but about twenty percent of our customers are women. Tourists and families also visit."

Why did you want to work at a maid café?
"I love to cosplay, or dress up as my favorite anime characters. Many of them wear maid outfits, so working here is like living in a cartoon. It's a fun and unique environment. I also like talking to the customers because they share my interests in manga and anime. I guess I'm a bit of an *otaku*."

Are many girls interested in working at a maid café?
"Oh yes – the last time a spot opened at MIA, we received over 200 applications. The manager looks for someone with a good, cheerful personality who works well with the rest of us."

What are some of your special or popular dishes?
"*Omerice* (omelet-rice) – fried rice wrapped in an omelet is always popular. We draw words and faces on the egg with ketchup. Our customers think it's adorable."

What do they typically request?
"Cute bunny or cat faces and the word *moe* (pronounced mow-eh)."

Riverside Seven Bldg,
3F, 2-7-9, Sotokanda,
Chiyoda-ku, Tokyo, Japan
Nearest station
Akihabara or Suehirocho
Open
Mon-Fri (12-10pm),
Sat-Sun (11am-10pm)
Telephone
03-6804-3771
URL
www.mia-cafe.com

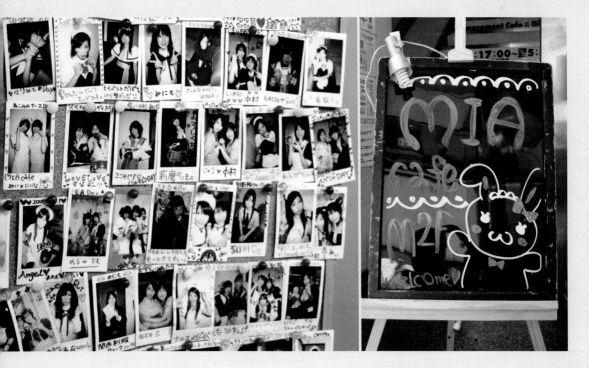

What does it mean?
"It translates as blossoming... it means the warm or happy feeling you get when you see a cute pet or sweet young girl."

So customers experience moe toward you when you give them special attention?
"Right. Most of our regulars have a favorite maid."

Do they ever try to ask you out?
"The customers are too shy. They are respectful; they know that this is a fantasy environment."

Why do you think they enjoy being waited upon by maids?
"They find it comforting – it's like entering the world of manga and anime – and we make them feel at home."

Are the Polaroid photos of the maids for sale?
"Yes – like most maid cafés, we don't allow customers to take photos. Instead, they can buy a *cheki* of their favorite maid and she'll decorate it."

What other special services do you offer?
"We'll stir sugar into your tea or coffee. Some maid cafés have games, hand massages, ear cleaning... We offer a lucky draw where the customer picks one card out of three. He might receive 200 yen off or collect points that can later be exchanged for a photo."

Can you tell me about the toy vending machine outside?
"It's called gachapon – you put in a few hundred yen and it spits out a round, plastic capsule. Inside, you might find a coupon or souvenir such as a keychain. Some of these designs are rare and have become collector's items."

What do you think is the biggest misconception about maid cafés?
"That there is something dirty or sexual about them. The customers feel happy in this space and we all enjoy working here."

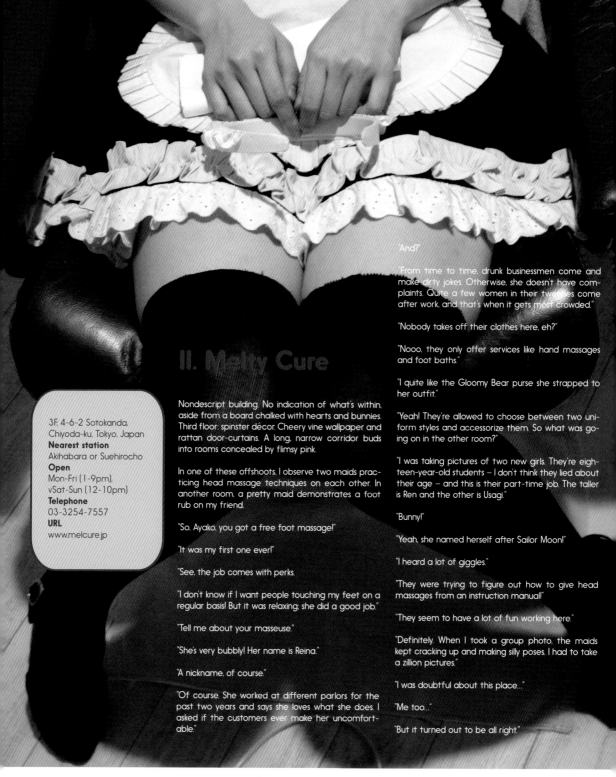

II. Melty Cure

3F, 4-6-2 Sotokanda,
Chiyoda-ku, Tokyo, Japan
Nearest station
Akihabara or Suehirocho
Open
Mon-Fri (1-9pm),
vSat-Sun (12-10pm)
Telephone
03-3254-7557
URL
www.melcure.jp

Nondescript building. No indication of what's within, aside from a board chalked with hearts and bunnies. Third floor: spinster décor. Cheery vine wallpaper and rattan door-curtains. A long, narrow corridor buds into rooms concealed by flimsy pink.

In one of these offshoots, I observe two maids practicing head massage techniques on each other. In another room, a pretty maid demonstrates a foot rub on my friend.

"So, Ayako, you got a free foot massage!"

"It was my first one ever!"

"See, the job comes with perks."

"I don't know if I want people touching my feet on a regular basis! But it was relaxing; she did a good job."

"Tell me about your masseuse."

"She's very bubbly! Her name is Reina."

"A nickname, of course."

"Of course. She worked at different parlors for the past two years and says she loves what she does. I asked if the customers ever make her uncomfortable."

"And?"

"From time to time, drunk businessmen come and make dirty jokes. Otherwise, she doesn't have complaints. Quite a few women in their twenties come after work, and that's when it gets most crowded."

"Nobody takes off their clothes here, eh?"

"Nooo, they only offer services like hand massages and foot baths."

"I quite like the Gloomy Bear purse she strapped to her outfit."

"Yeah! They're allowed to choose between two uniform styles and accessorize them. So what was going on in the other room?"

"I was taking pictures of two new girls. They're eighteen-year-old students – I don't think they lied about their age – and this is their part-time job. The taller is Ren and the other is Usagi."

"Bunny!"

"Yeah, she named herself after Sailor Moon!"

"I heard a lot of giggles."

"They were trying to figure out how to give head massages from an instruction manual!"

"They seem to have a lot of fun working here."

"Definitely. When I took a group photo, the maids kept cracking up and making silly poses. I had to take a zillion pictures."

"I was doubtful about this place..."

"Me too..."

"But it turned out to be all right."

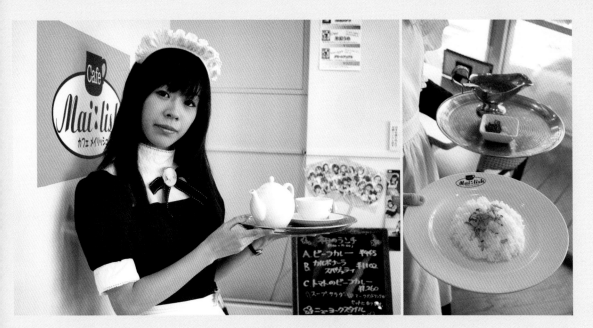

III. Café Mailish

Maid café vernacular. The curry rice, the calorie-laden floats, the emanations of French maid costumes and greetings of "Welcome home, Master/Mistress." Omerice too hot? A maid will blow on it and spoonfeed the customer, baby-talking all the while. At this point – ho hum. I ask the manager, Mr. Sasaki, What makes Café Mailish stand out from the pack?

"We don't have high staff turnover, so our customers think of the maids as family. Each is charming in her own way. Some wear glasses; some put their hair in pigtails or two braids. Some are mischievous; some are demure. We've turned each girl into an anime character and put her likeness on our merchandise – towels, ashtrays, giant posters."

"Anything else unique about Mailish?"

"We have special events during festive seasons and to promote the release of an anime or movie. Every year, we hold a graduation ceremony for students from a fictitious French high school. There's also the popular Mini-Skirt Policewoman Day..."

FH Kyowa Square Bldg. 2F,
3-6-2 Sotokanda,
Chiyoda-ku, Tokyo, Japan
Nearest station
Akihabara or Suehirocho
Open
Daily (11am-10pm)
Telephone
03-5289-7310
URL
www.mailish.jp

IV. Cos-Cha Café

**Isamiya Dai 8 Bldg, 2F,
3-7-12, Sotokanda,
Chiyoda-ku, Tokyo, Japan**
Nearest station
Akihabara or Suehirocho
Open
Daily (5-10pm)
Telephone
03-3253-4560
URL
www.cos-cha.com

Classroom twist on the *meido* theme: green chalkboard, shoe cubby, rows of flip-top desks. The baristas are called "angels" and draw cute faces in cappuccino foam. A twelve-year-old boy – still in his school uniform – munches on a sandwich with chipmunk cheeks.

Not much of a story during lunch hour. "Come back in the evening!" calls an angel. "That's when things get wild and crazy."

Nighttime at Cos-Cha. Tables of boys in anime t-shirts I make a beeline to the one with straight black bangs and round glasses. Something about him screams kamikaze.

He's Toshi, a college student. Spent the afternoon at a gaming center with his two nebbish friends. Does he consider himself an *otaku*? Toshi twiddles his straw.

"I like video games, but so do a lot of people."

His two buddies shove his shoulders and whoop. "What? Come on! You are such an *otaku!* You never shut up about your idols and your collection of vinyl figures. How many do you have now, three hundred?"

What brings you to Cos-Cha tonight?

"A lot of us come here. It's a cozy environment, and it's nice to chat with the maids."

Again, his friends laugh and slap the table.

"What a liar! He comes here for the *Janken* Mixed Juice Challenge! 2500 yen, he'll pay for this!"

The what? An angel named Sakura swishes over with an empty glass and a silver platter of ingredients. Heads turn.

She initiates a game of *janken* (rock-paper-scissors). Toshi wins the first round, so he gets to choose the base of his drink. He picks milk. The server's paper beats his rock, causing Toshi's friends to chant, *"Natto! Natto!"* She giggles and obliges: in goes a termite-like glob of fermented soybeans. Toshi loses again. Sakura mixes in slimy seaweed.

Toshi picks up the glass with both hands and tries to down it in one gulp. The *natto* splashes onto his glasses; he chokes. "Ohh!" cries the crowd, *"Batsu* (punishment)!" The delicate angel obliges... by whacking Toshi across the face. Not a playful tap, but a full-blown slap.

Game over. Toshi wipes his glasses – flashing a devlish grin.

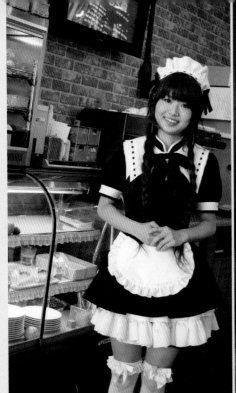

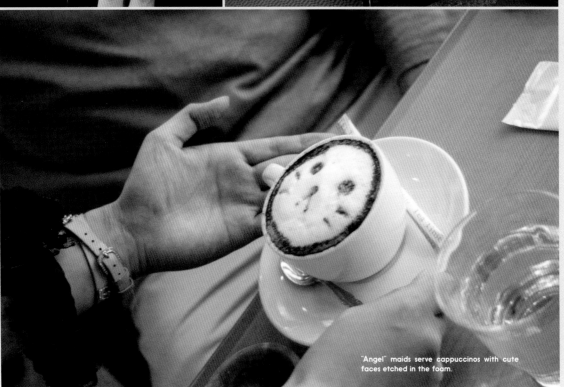

"Angel" maids serve cappuccinos with cute faces etched in the foam.

Maids and Cosplay

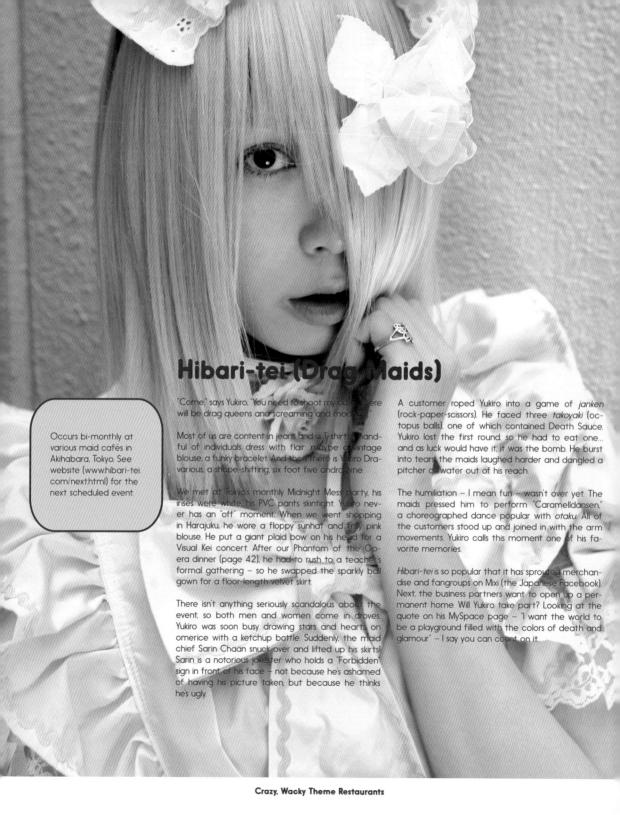

Hibari-tei (Drag Maids)

Occurs bi-monthly at various maid cafés in Akihabara, Tokyo. See website (www.hibari-tei. com/next.html) for the next scheduled event.

"Come," says Yukiro. "You need to shoot my café, there will be drag queens and screaming and mooning."

Most of us are content in jeans and a T-shirt. A handful of individuals dress with flair: maybe a vintage blouse, a funky bracelet. And then there is Yukiro Dravarious, a shape-shifting, six foot five androgyne.

We met at Tokyo's monthly Midnight Mess party, his irises were white, his PVC pants skintight. Yukiro never has an "off" moment. When we went shopping in Harajuku, he wore a floppy sunhat and frilly pink blouse. He put a giant plaid bow on his head for a Visual Kei concert. After our Phantom of the Opera dinner (page 42), he had to rush to a teacher's formal gathering – so he swapped the sparkly ball gown for a floor-length velvet skirt.

There isn't anything seriously scandalous about the event, so both men and women come in droves. Yukiro was soon busy drawing stars and hearts on omerice with a ketchup bottle. Suddenly, the maid chief Sarin Chaan snuck over and lifted up his skirts! Sarin is a notorious jokester who holds a "Forbidden" sign in front of his face – not because he's ashamed of having his picture taken, but because he thinks he's ugly.

A customer roped Yukiro into a game of *janken* (rock-paper-scissors). He faced three *takoyaki* (octopus balls), one of which contained Death Sauce. Yukiro lost the first round, so he had to eat one... and as luck would have it, it was the bomb. He burst into tears, the maids laughed harder and dangled a pitcher of water out of his reach.

The humiliation – I mean fun – wasn't over yet. The maids pressed him to perform "Caramelldansen," a choreographed dance popular with *otaku*. All of the customers stood up and joined in with the arm movements. Yukiro calls this moment one of his favorite memories.

Hibari-tei is so popular that it has sprouted merchandise and fangroups on Mixi (the Japanese Facebook). Next, the business partners want to open up a permanent home. Will Yukiro take part? Looking at the quote on his MySpace page – "I want the world to be a playground filled with the colors of death and glamour" – I say you can count on it.

Nowhere on the chalkboard does it say that the maids are in fact men.

Maids and Cosplay

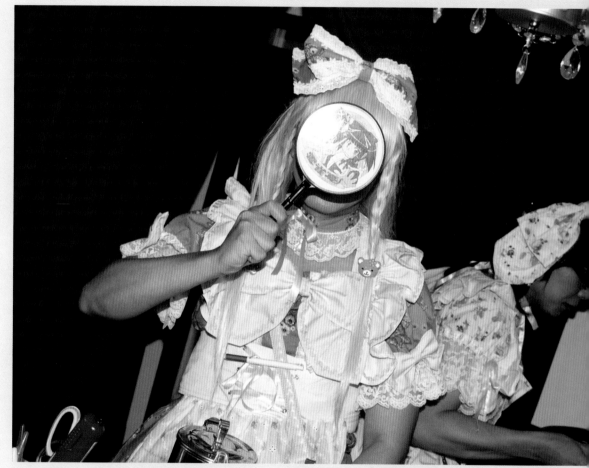

The chief maid goes to great lengths to hide
his face.

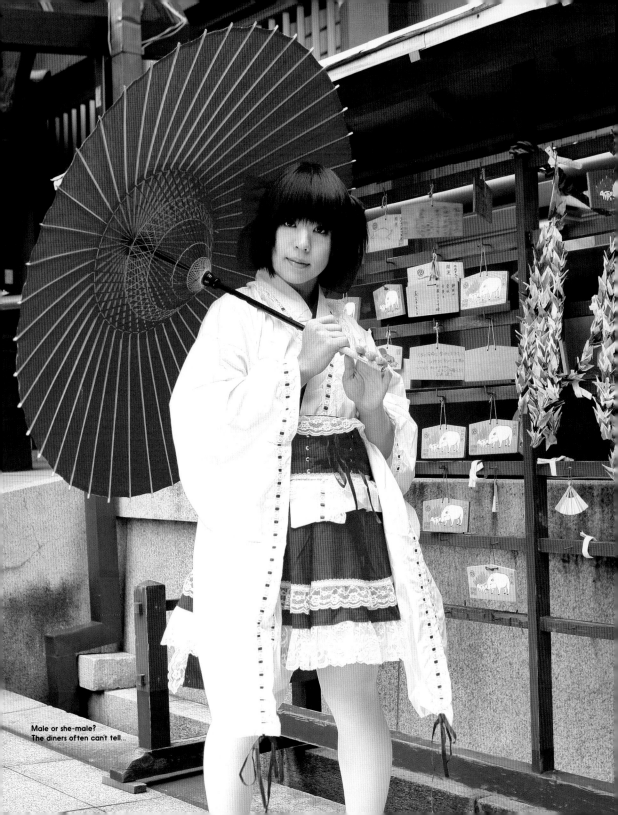

Male or she-male?
The diners often can't tell...

Love-all

Love All (Suits and Spectacles)

Sunrise Bldg. B1, 3-16-10
South (Minami) Ikebukuro,
Toshima-ku, Tokyo, Japan
Nearest station: Ikebukuro
Open
Mon-Fri (4-11pm),
Sat-Sun (public: 11-4pm,
private: 5-11pm)
Telephone
03-3986-2275
URL
www.love-all.co.jp

Dear Niece,

Don't be silly! I am not disappointed in you, as you wrote in your letter to me (page 30). Auntie means best, that's all. Not sold on a Little Hong Kong theme wedding – I prefer without the "little" and "theme" – but it's a start. Compromise is good.

But like you said, good to combine Tokyo theme and Asian tradition. I did research, and I think you should try the Love-All Café in Ikebukuro.

Inside is like a modern loft, like the one my other niece – who graduated from Stanford – moved into with her Chinese husband. And the staff – they dress nice! Suit and tie. All of them wear glasses; they even draw a ketchup "spectacles bear" on your *omerice*. They give you a name card to wear around your neck so you can pretend you work at a big company. How the waiter treats you depends on the card you choose: older employee, younger, same age, client.

I still have nightmares about the love hotels you told me about, but the "suits and spectacles" fetish I understand. The manager started a group on Mixi (the Japanese Facebook), where people post photos of these smart, decent boys. It became so popular that he published a book and opened this café as a place for otaku to relax. It is the only one of this theme in Japan.

These boys aren't real scientists, and some don't even have prescription glasses. But it's a start. Like the young women who come to Love-All, you can get used to their smart company. Then maybe you can meet my friend's son. He graduated from Princeton and is working in Hong Kong business. Good to keep options open, right?

Dress warm and eat right!
Auntie Wanda

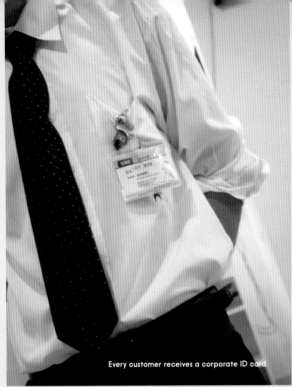

Every customer receives a corporate ID card.

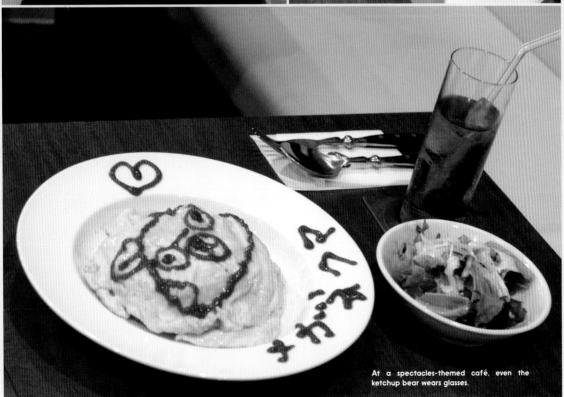

At a spectacles-themed café, even the ketchup bear wears glasses.

Maids and Cosplay

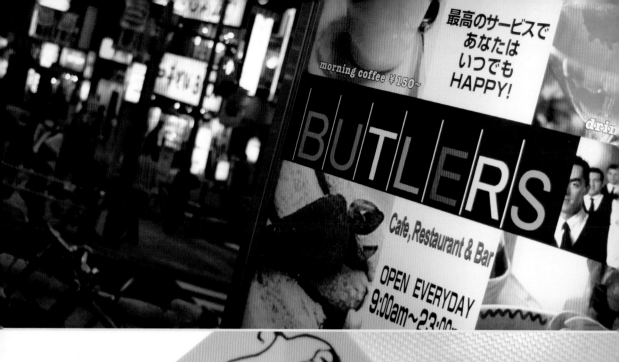

最高のサービスで
あなたは
いつでも
HAPPY!

morning coffee ¥150~

drin

BUTLERS

Cafe, Restaurant & Bar

OPEN EVERYDAY
9:00am~23:00

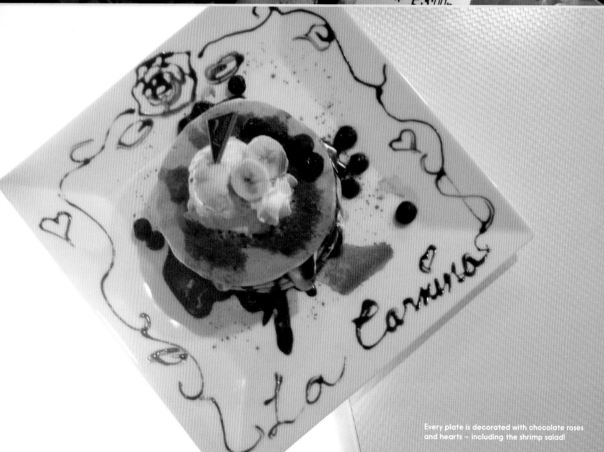

Every plate is decorated with chocolate roses
and hearts – including the shrimp salad!

Crazy, Wacky Theme Restaurants

I'm greeted by a choir of vests and bow ties: "Good evening, my Princess! Oh my goodness, you look so lovely". Pierre (an Australian student not named Pierre) ushers me by the arm to a pink table. The giant smile, the eager eyebrows, the dimples and epic hair... why does he remind me of a long lost love? And then it hits me: He's the splitting image of Prince Eric from The Little Mermaid. My kindergarten dream boy has returned to serve me dinner.

Pierre describes the specials: for 4,000 yen, we can practice English phrases together. For 1,000 yen, he'll lift me in the air for a souvenir photo. The Cinderella treatment costs 2,000 yen: the butlers dim the lights and search for their Princess, who receives a special meal.

"Whenever you need me, just tinkle the gold bell," he beams.

I ring. "YES my Princess!" cries "Pierre," dropping to one knee with hands clasped.

"I've decided on the Image Cocktail."

"Wonderful, my Princess! It is a mirror that reflects your hopes and dreams, so let me ask you a few questions. First of all, is alcohol all right?"

"Oh YES, my butler."

"What is your favorite season?"

"Probably autumn because of Halloween."

"And which country would you most like to visit?"

"Egypt's on my list."

He returns with the drink hidden behind a silver platter. "Close your eyes... and BAM!" – he whips out a towering sweet cocktail. The colors are appropriately dark and murky.

Pierre asks me to fill out a piece of paper asking why I came to the café. I mark the box next to "I want to cry."

"Oh dear! What's wrong, my Princess?"

"Drama and scandal," I fake-wail, "and looming deadlines!"

"Oh my Princess!" He gives me his best puppy-dog eyes. "In this space, you are safe and in good hands."

He scans the paper; I also ticked "Checking you out."

"The translation is a little off," he explains. "In Japanese, it simply means you've dropped by for a visit. But I'm flattered, Princess!"

"What would you do if a customer... slipped you her number?"

"Ah, that happens from time to time, but it's against the owner's policy."

The owner did her research: before settling on the foreign butler theme, Yuki Hirohata interviewed two hundred girls in Shibuya. She learned that they wanted a place to practice English and meet good-looking *gaijin* (foreigners).

For these reasons, Nakata, a woman in her late 30s, eats here most every day. Her butler (also a student from Melbourne) pours tea and serves her crepes with "Queen Yuko" written on the plate in chocolate swirls. He places a tiara on her head and leads her by the hand to the restroom.

I can barely contain an eye-roll. Better to go through the daytime TV dramas of dating than live happily ever after with Jeeves.

Aicom Shibuya Bldg. 5F,
11-6 Udagawa,
Shibuya-ku, Tokyo, Japan
Nearest station
Shibuya
Open
Tues-Fri
(12-4:30pm, 6-11pm),
Sat-Sun & holidays
(12-11pm)
Telephone
03-3780-6883
URL
www.butlerscafe.com

Café Edelstein (Schoolboy)

Champs-Élysées Bldg. 2F,
4-28-14 Jingumae,
Harajuku-ku, Tokyo, Japan
Nearest station
Harajuku
Open
Daily (10am-5pm),
Mon-Thurs & Sun
(6-9:30pm),
Fri-Sat (6-11pm)
Telephone
03-5573-8673
(reservations recommended)
URL
www.cafe-edelstein.com

It's impossible to guess his real age. He's the splitting image of a *bishonen* or beautiful youth, complete with pink gloss on his lips and wayward hair over his eyes. His school uniform – crested jacket over velvet cravat, snug checkered pants – comes straight from the pages of Harry Potter. He speaks with excruciating politesse and bows at a ninety-degree angle. When I order a champagne cocktail, the boy puts a manicured hand over his mouth.

"Oh gosh!" he whispers. "I am but a schoolboy; I know nothing of alcohol. Please, I beg you to wait while I consult my headmistress."

Okay, it's sort of wrong – but I must admit I like being waited upon by "youngsters." While I wait for my cocktail, my schoolboy practices a piano piece and purposefully makes clunkers. His classmate "Gilbert" leans on the windowsill, pretending to study a velvet tome of school regulations.

I'm in a charming world straight out of a *manga* subset called *yaoi* (yow-ee, also known as Boy's Love or *shonen-ai*). These stories explore the anguished emotional relations between young men, often with explicit love scenes. The creators and consumers of *yaoi*, however, are generally young heterosexual females.

Twenty-something Emiko Sakamaki opened the café for *fujoshi*, or female manga-lovers with little interest in maid cafés. "These women are in their twenties or thirties, and want to escape the drudgery of workplace," she says. "Edelstein re-creates the romance and fragility of *yaoi* – which we too rarely see in real life."

The boys in my life certainly don't pour me Earl Grey tea and awkwardly place a ginger biscuit on the plate. I ask "Serge" whether he has a girlfriend, causing him to shake his head emphatically. "Oh dear! I hardly know any girls... I am too busy with school and piano lessons."

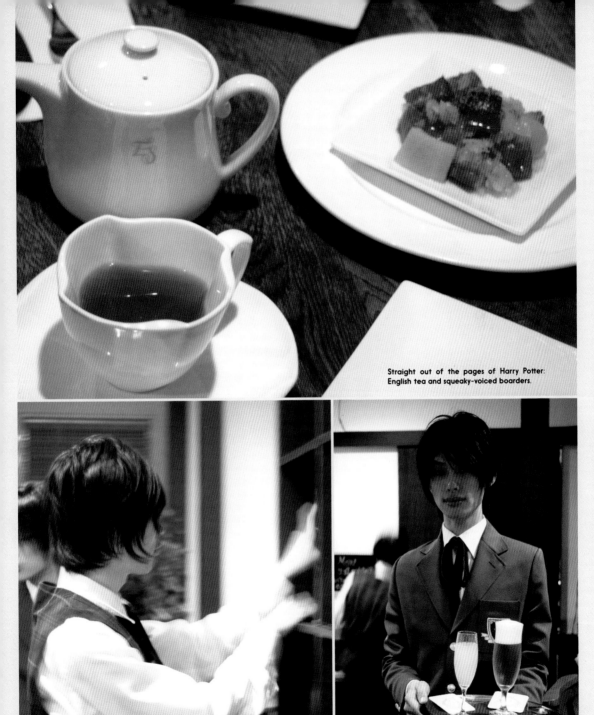

Straight out of the pages of Harry Potter:
English tea and squeaky-voiced boarders.

Chapter 6
Tipsy Theme Bars

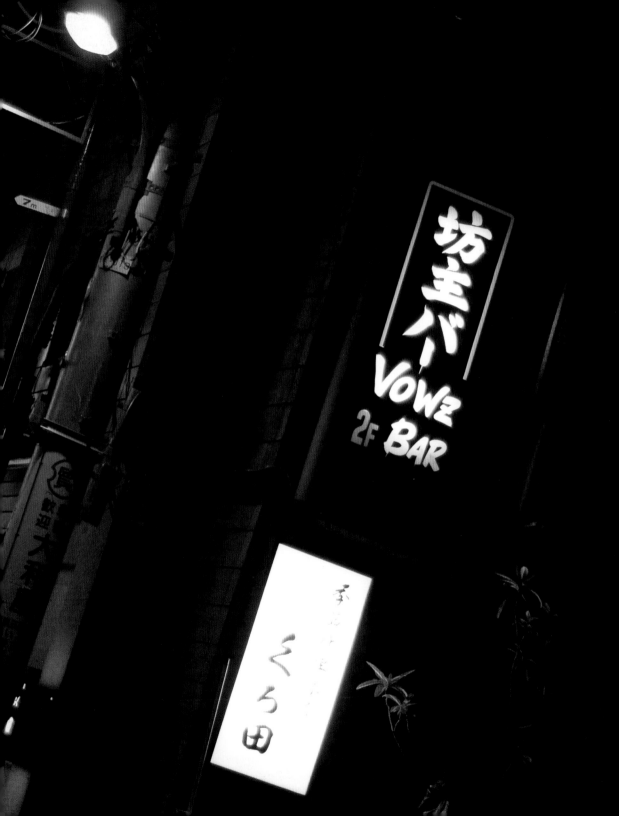

Vowz (Buddhist Priest)

AG Bldg 2F, 6-42 Arakicho,
Shinjuku-ku, Tokyo, Japan
Nearest station
Yotsuya San-chome
Open
Mon-Sat (7 pm-1am)
Telephone
03-3353-1032

"Yeah, that's the owner," sighs the bartender.

"Him?" I point at a portly man wearing sunglasses in-doors. He's perched on a barstool, smoking and joking with the handful of customers.

"How exactly does that work?"

"What do you mean?"

"I mean, I could be a crazy person but... isn't he a Buddhist priest?"

The man has draped a sash and traditional robes over a polyester disco shirt. He wears rosary beads next to his digital wristwatch. One of the bar's three *butsudan* shrines sits next to a shelf of hard liquor.

"Yeah," she yawns. "He's part of the Jodo Shin sect. Smoking and drinking and eating meat are pretty much okay, so they opened up three bars. After 9pm, he'll discuss the teachings with young monks or who-ever stumbles in here. Do you want to ask the *bozu* (Buddhist priest) a question?

He's coughing from the mix of tobacco and incense. The *bozu* picks up his beer and feels his way over to the chair. It takes me a minute to realize he's been blind since birth. He's also a tad deaf –
"So make sure you yell into my hearing aid!"

"*Bozu*, please tell me about love!"

"LOVE!" He chortles, exposing gold-capped buck-teeth. "There are two types of love: human and god love. Human love requires some sort of reciprocation, but Amida Buddha's mercy is directed at everyone, no matter your station in life or whether you do any-thing in return..."

Or you can order another round of cocktails. He picks sweet, pink Heaven; I choose the dark, hot pepper Hell of Burning Desire. "*Kampai*!"

"May I take photos of you?"

"Sure, sure, but promise me you won't cut out my face and stick it on a Most Wanted poster? Some-one did that as a joke, and once in a samsaric life-time is enough..."

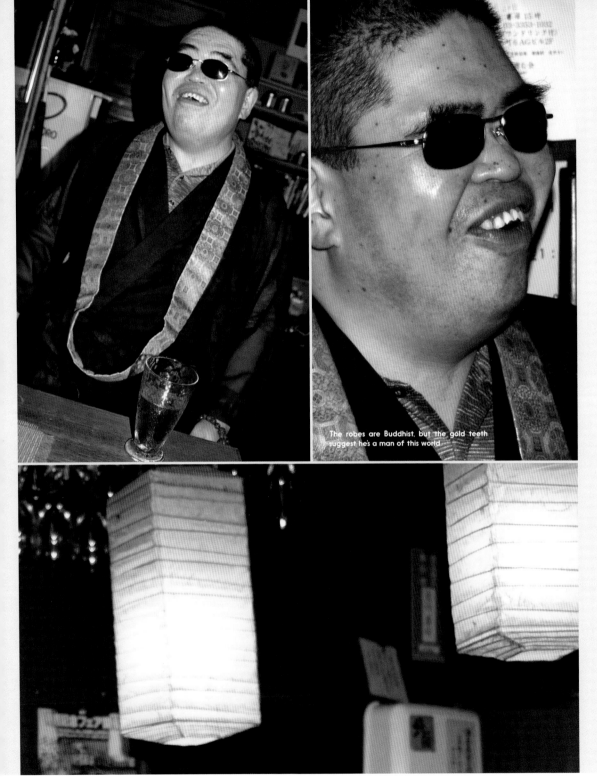

The robes are Buddhist, but the gold teeth suggest he's a man of this world

Tipsy Theme Bars

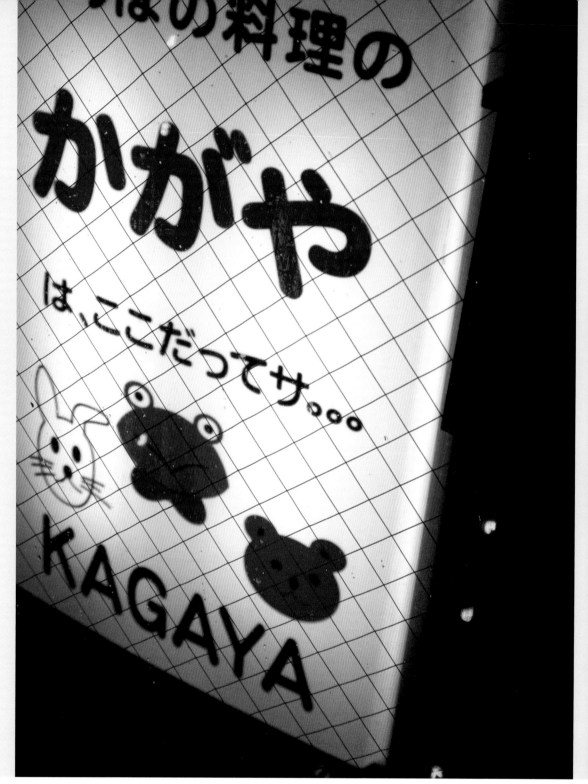

Kagaya (Puppets and Costumes)

K-A-G-A-Y-A spells the maddest bar in Tokyo, if not the galaxy.

K is for Kindergarten...
The tatami-matted space is dead empty other than a clean-cut young man crammed into the kitchen. He straightens his blue apron and curtly introduces himself as Mark Kagaya. He excuses himself and disappears behind a *noren* (Japanese cloth curtain hanging over a doorway).

Suddenly, we hear him screech, "Beep, boop, boop!" Out comes a two-foot tall anime character with two hot towels on his bread roll head. Mark controls the toy with a handheld remote and deliberately crashes it into our table.

"Hello, my name is Anpanman!" he squeaks, "What's your name?" He whizzes the toy in the air: "Waaahh! Waahhhh! Swooosh!" Before we can respond, Mark has retreated into the nook. "La dah um dah um..." he hums.

A is for Absurdity...
Normal Mark emerges with the drink menu. He kneels, spreads it on our table and proceeds to mime all the offerings. Mark raises a fist to his mouth and tilts back his head ("Glub, glub, glub...") and strokes the flower on the cover ("Sake so sexy, oh so sexy...").

We're asked to pick one of the countries scrawled on the menu in crayon to determine the method of delivery. Tim points at "Brazil." Mark disappears once again behind the curtain.

Tropical music blasts. A lunatic bursts out with rainbow-colored feathers over his sleeves and an octopus on his head. He jigs around the room, whacking us with a long white flag while screeching "Woo hoo! Woo hoo!"

The octopus-man brings out our drinks. Tim's beer mug wobbles when he lifts it, causing foam to splatter all over his chin. My sake comes out of a bottle that resembles a peeing cherub.

G is for Games...
Mark takes out a bubble blower and retro games. Can we thread a metal pointer through a web without getting shocked? Or manipulate a silver ball through the maze of evolution: bacteria, jellyfish, pig, Einstein? Or insert plastic keys into a pirate without triggering a squirt of water to the face?

A is for Adult Content...
We ask for the food menu. Mark kneels with a monkey puppet and puts on a one-man, many-voiced show.

Monkey: Welcome to Kayaga! Let me help you to a seat.

Drunk Customer: Blahh! Me want food and me want it NOW!

Hanasada Bldg, B1F,
5-12 Shimbashi 2-Chome,
Minato-Ku, Tokyo, Japan
Nearest station
Shimbashi
Open
Daily (6pm-late)
Telephone
03-3591-2347
URL
www1.ocn.ne.jp/~kagayayy

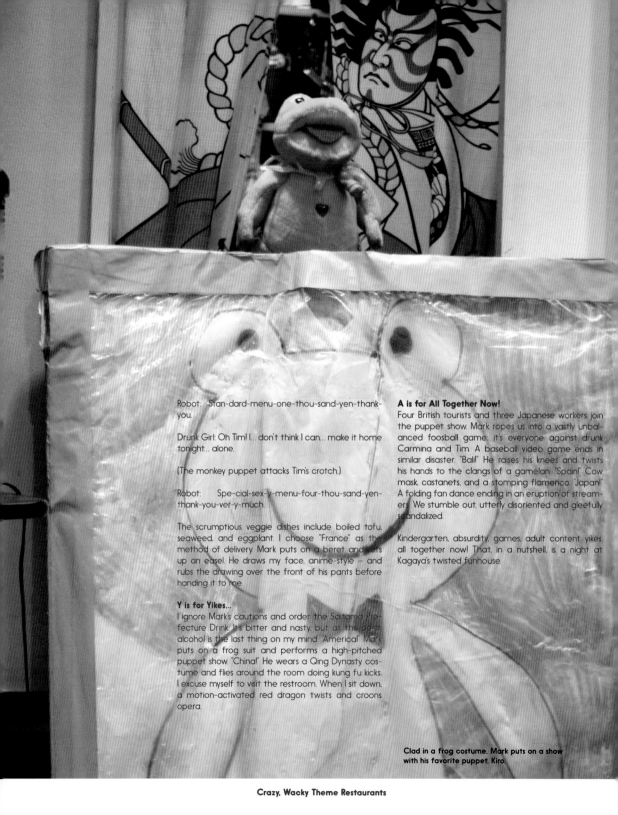

Robot: Stan-dard-menu-one-thou-sand-yen-thank-you.

Drunk Girl: Oh Tim! I... don't think I can... make it home tonight... alone.

(The monkey puppet attacks Tim's crotch.)

Robot: Spe-cial-sex-y-menu-four-thou-sand-yen-thank-you-ver-y-much.

The scrumptious veggie dishes include boiled tofu, seaweed, and eggplant. I choose "France" as the method of delivery. Mark puts on a beret and sets up an easel. He draws my face, anime-style – and rubs the drawing over the front of his pants before handing it to me.

Y is for Yikes...

I ignore Mark's cautions and order the Saitama Prefecture Drink. It's bitter and nasty, but at this point, alcohol is the last thing on my mind. "America!" Mark puts on a frog suit and performs a high-pitched puppet show. "China!" He wears a Qing Dynasty costume and flies around the room doing kung fu kicks. I excuse myself to visit the restroom. When I sit down, a motion-activated red dragon twists and croons opera.

A is for All Together Now!

Four British tourists and three Japanese workers join the puppet show. Mark ropes us into a vastly unbalanced foosball game: it's everyone against drunk Carmina and Tim. A baseball video game ends in similar disaster. "Bali!" He raises his knees and twists his hands to the clangs of a gamelan. "Spain!" Cow mask, castanets, and a stomping flamenco. "Japan!" A folding fan dance ending in an eruption of streamers. We stumble out, utterly disoriented and gleefully scandalized.

Kindergarten, absurdity, games, adult content, yikes, all together now! That, in a nutshell, is a night at Kagaya's twisted funhouse.

Clad in a frog costume, Mark puts on a show with his favorite puppet, Kiro.

Crazy, Wacky Theme Restaurants

Traditional Japanese dishes are served along-
side retro fighting games.

Chapter 7
Animal-Mania

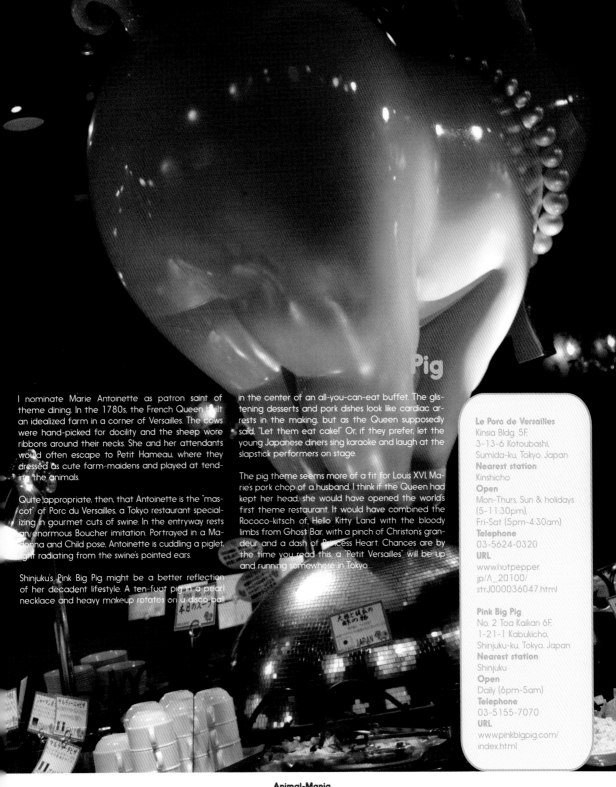

Pig

I nominate Marie Antoinette as patron saint of theme dining. In the 1780s, the French Queen built an idealized farm in a corner of Versailles. The cows were hand-picked for docility and the sheep wore ribbons around their necks. She and her attendants would often escape to Petit Hameau, where they dressed as cute farm-maidens and played at tending the animals.

Quite appropriate, then, that Antoinette is the "mascot" of Porc du Versailles, a Tokyo restaurant specializing in gourmet cuts of swine. In the entryway rests an enormous Boucher imitation. Portrayed in a Madonna and Child pose, Antoinette is cuddling a piglet, light radiating from the swine's pointed ears.

Shinjuku's Pink Big Pig might be a better reflection of her decadent lifestyle. A ten-foot pig in a pearl necklace and heavy makeup rotates on a disco ball

in the center of an all-you-can-eat buffet. The glistening desserts and pork dishes look like cardiac arrests in the making, but as the Queen supposedly said, "Let them eat cake!" Or, if they prefer, let the young Japanese diners sing karaoke and laugh at the slapstick performers on stage.

The pig theme seems more of a fit for Louis XVI. Marie's pork chop of a husband. I think if the Queen had kept her head, she would have opened the world's first theme restaurant. It would have combined the Rococo-kitsch of Hello Kitty Land with the bloody limbs from Ghost Bar, with a pinch of Christon's grandeur and a dash of Princess Heart. Chances are by the time you read this, a "Petit Versailles" will be up and running somewhere in Tokyo.

Le Porc de Versailles
Kinsia Bldg. 5F.
3-13-6 Kotoubashi,
Sumida-ku, Tokyo, Japan
Nearest station
Kinshicho
Open
Mon-Thurs, Sun & holidays
(5-11:30pm),
Fri-Sat (5pm-4:30am)
Telephone
03-5624-0320
URL
www.hotpepper.
jp/A_20100/
strJ000036047.html

Pink Big Pig
No. 2 Toa Kaikan 6F.
1-21-1 Kabukicho,
Shinjuku-ku, Tokyo, Japan
Nearest station
Shinjuku
Open
Daily (6pm-5am)
Telephone
03-5155-7070
URL
www.pinkbigpig.com/
index.html

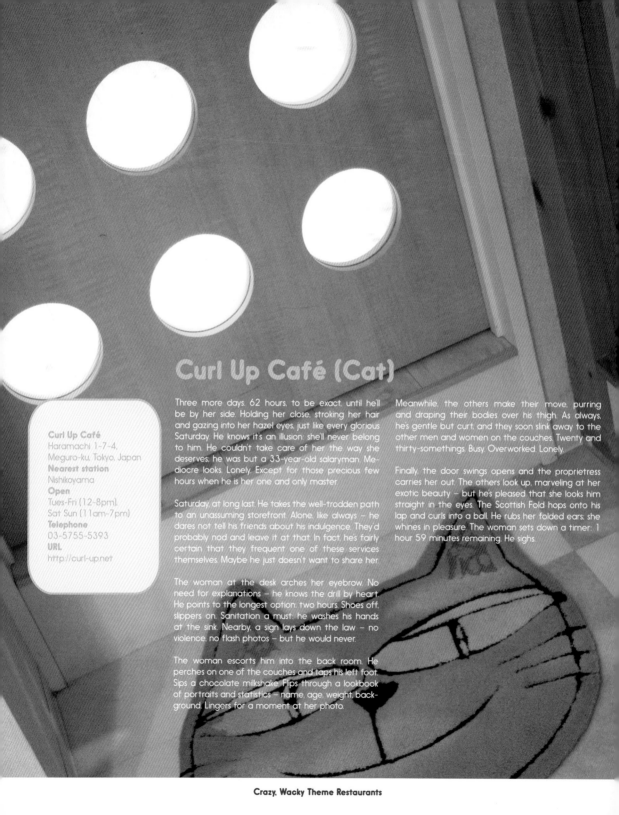

Curl Up Café (Cat)

Curl Up Café
Haramachi 1-7-4,
Meguro-ku, Tokyo, Japan
Nearest station
Nishikoyama
Open
Tues-Fri (12-8pm),
Sat Sun (11am-7pm)
Telephone
03-5755-5393
URL
http://curl-up.net

Three more days. 62 hours, to be exact, until he'll be by her side. Holding her close, stroking her hair and gazing into her hazel eyes, just like every glorious Saturday. He knows it's an illusion: she'll never belong to him. He couldn't take care of her the way she deserves; he was but a 33-year-old salaryman. Mediocre looks. Lonely. Except for those precious few hours when he is her one and only master.

Saturday, at long last. He takes the well-trodden path to an unassuming storefront. Alone, like always – he dares not tell his friends about his indulgence. They'd probably nod and leave it at that. In fact, he's fairly certain that they frequent one of these services themselves. Maybe he just doesn't want to share her.

The woman at the desk arches her eyebrow. No need for explanations – he knows the drill by heart. He points to the longest option: two hours. Shoes off, slippers on. Sanitation a must: he washes his hands at the sink. Nearby, a sign lays down the law – no violence, no flash photos – but he would never.

The woman escorts him into the back room. He perches on one of the couches and taps his left foot. Sips a chocolate milkshake. Flips through a lookbook of portraits and statistics – name, age, weight, background. Lingers for a moment at her photo.

Meanwhile, the others make their move, purring and draping their bodies over his thigh. As always, he's gentle but curt, and they soon slink away to the other men and women on the couches. Twenty and thirty-somethings. Busy. Overworked. Lonely.

Finally, the door swings opens and the proprietress carries her out. The others look up, marveling at her exotic beauty – but he's pleased that she looks him straight in the eyes. The Scottish Fold hops onto his lap and curls into a ball. He rubs her folded ears; she whines in pleasure. The woman sets down a timer: 1 hour 59 minutes remaining. He sighs.

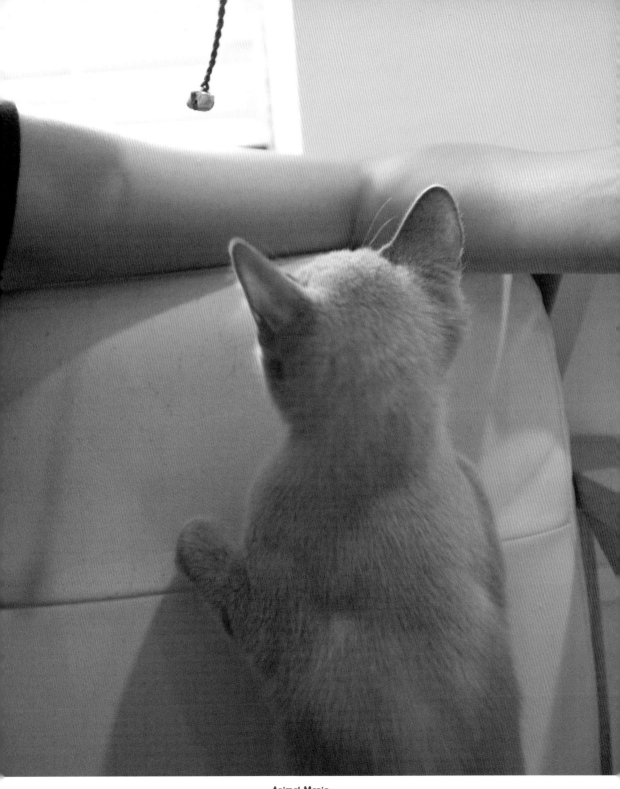

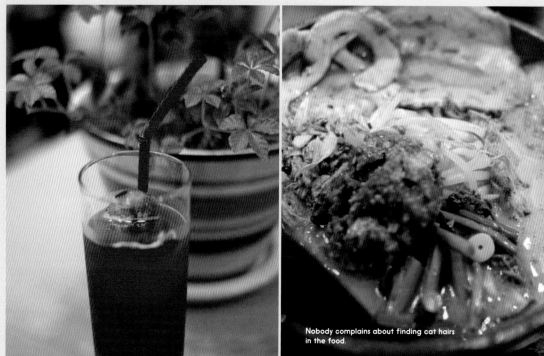

Nobody complains about finding cat hairs in the food.

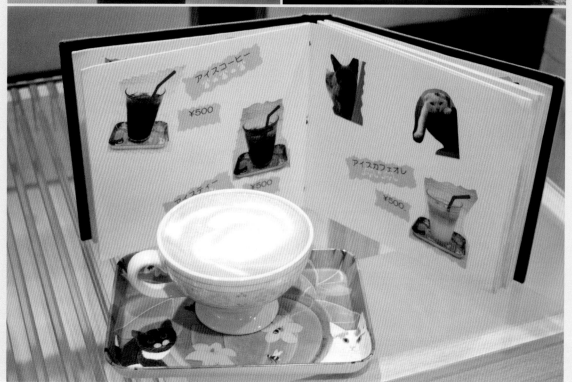

Crazy, Wacky Theme Restaurants

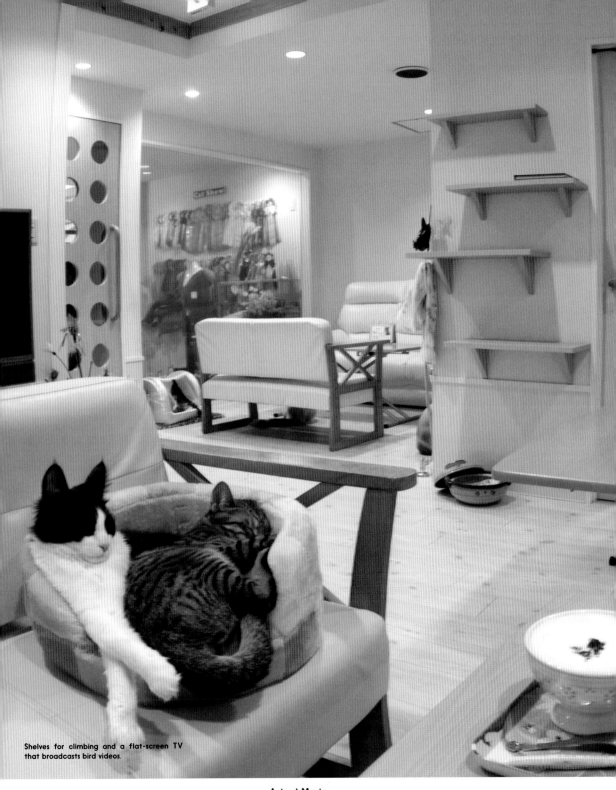

Shelves for climbing and a flat-screen TV
that broadcasts bird videos.

Deco's Dog Café

Chofu 2-62-1,
Den-en-Chofu,
Tokyo, Japan
Nearest station
Den-en-Chofu
Open
Daily (9am-8pm)
Telephone
03-3722-5033
URL
www.hot-dog.co.jp

I instant message my friend Melissa, a Los Angeles feminist filmmaker, most every day to discuss the various scandals and dramas that happily plague our lives. One afternoon, I tell her I am about to shoot a dog café for my book.

"Hey, did I tell you I'm getting a Chihuahua?" she types. "I found one for free on Facebook."

Such things only happen to Melissa. I press her for details: "A dog can be a lot of work."

"Yeah, but it's going to die soon. It's thirteen years old."

"Ah, I see. So we can give it a grand Gothic Lolita funeral."

"Exactly! I'll get to cuddle it and satisfy my need for dressing up small things, and then it'll die and I can still go travel. It's perfect."

Melissa's dog wouldn't be the only pooch with a designer wardrobe in LA, home to Paris Hilton's growing kennel and Jessica Simpson's maltipoo, Daisy.
But as with its theme restaurants, Japan takes dog pampering to the extreme. I ride the Tokyu Toyoko line to what I expect to be a harmless suburb. I've survived S&M parties and walked red light districts alone and half-blind (literally – one of my contacts fell out) – but never have I ever encountered a place as terrifying as Den-en-Chofu. The station is tomb-quiet and looks like it's been soaked in Purell,

and there are two types of surrounding shops: hair salons and chic patisseries. Beyond, I see nothing but the rooftops of detached suburban villas.

I follow a corgi through a glass door and find two canine clothing stores (carrying every style from hip-hop to princess) a hotel, grooming salon (in the window, a poodle is getting a perm), and Deco's Dog Café.

"It was horrible, horrible!" I type to Melissa later that day.

"Really? Tell me!"

"These ladies at the café... I don't know! It was all women, mostly in their thirties, lunching with tiny dogs in designer clothes. It was like Valley of the Dogs."

"That's awesome!"

"I know, it was totally Sharon Tate. Take the menu, for instance – every dish had a specific calibration of vitamins and minerals and came with the calorie count."

"You could eat the exact same food as your dog?"

"I think so... it seemed pretty interchangeable. I couldn't drink the water; it tasted like dog."

The Den-en-Chofu dogs become my latest morbid fascination. I find it hard to glean insight from

Every "Stepford dog" I encountered wore some sort of frilly clothing.

their owners, who give the stock answer: "It's cute and fun." Robot zombie conspiracies aside, what's the real story?

Conspicuous consumption is part of the story. Many attribute the trend to Crown Princess Masako, who appeared on TV with her terrier, Chocolat, in the mid-1990s. From 2000 onward, the recovering economy spurred pet owners to splurge on the growing crop of luxury products. And most condominiums banned pets a decade ago, but the opposite is true today.

For an increasing number of Japanese working women, tiny dogs have become stand-ins for husbands and children. The ladies at the café admit to spending thousands of dollars a year on their surrogate babies: on business cards, weddings, hotels, nannies, *onsen* (hot spring baths), massages, and yoga lessons. Detractors call these services frivolous – but do they cause any real harm?

It depends, I suppose. Does dressing your dog in a bonnet and naming him Mince constitute animal abuse?

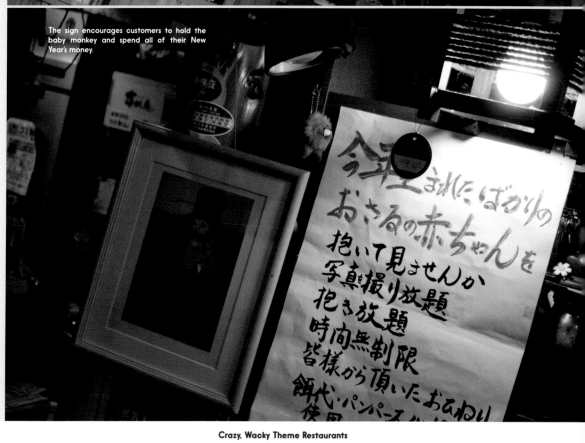

The sign encourages customers to hold the baby monkey and spend all of their New Year's money.

Crazy, Wacky Theme Restaurants

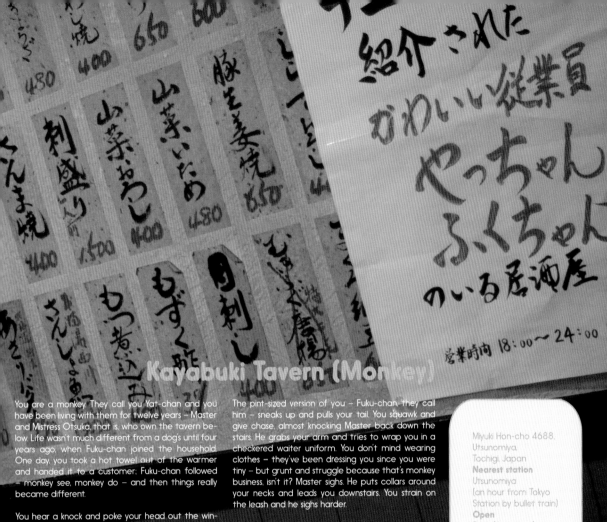

Kayabuki Tavern (Monkey)

You are a monkey. They call you Yat-chan and you have been living with them for twelve years – Master and Mistress Otsuka, that is, who own the tavern below. Life wasn't much different from a dog's until four years ago, when Fuku-chan joined the household. One day, you took a hot towel out of the warmer and handed it to a customer; Fuku-chan followed – monkey see, monkey do – and then things really became different.

You hear a knock and poke your head out the window. Some foreign girl who sort of looks like a panda – it's the black smudged around her eyes – spots you and calls: "Yat-chan!" You're not alarmed. Recently, strangers have been stopping by with cameras almost every day.

Master swipes a comb through his hair and scrambles down the stairs. You know the drill: the Japanese news clippings gradually accumulated on the wall, but the foreign ones multiplied overnight. "I saw them on YouTube," you hear her say.

Master is speaking too loudly: "They were on BBC and CNN, and look, there's even a manga about them!" Of course, he's showing her the framed portrait of you in a handlebar moustache, top hat, and oversized bow tie. You can't understand why everyone likes the photo so much when all the objects obscure your face.

The pint-sized version of you – Fuku-chan, they call him – sneaks up and pulls your tail. You squawk and give chase, almost knocking Master back down the stairs. He grabs your arm and tries to wrap you in a checkered waiter uniform. You don't mind wearing clothes – they've been dressing you since you were tiny – but grunt and struggle because that's monkey business, isn't it? Master sighs. He puts collars around your necks and leads you downstairs. You strain on the leash and he sighs harder.

Every stranger must meet your approval before entering your territory. You tip-toe around the bar, and one look is enough to send you scurrying back behind Master. *Hiss! Hiss!* You've seen humans of all sizes and skin colors, but this... this is simply bananas. The girl is wearing a headpiece with ears attached to the side. She's smeared dark makeup around her face and on her nose to resemble a monkey. *You growl. I'm top macaque around here – so don't you go around aping me!* Master quickly gets her to remove the fake ears. "I should have dressed like the Man in the Yellow Hat," she shrugs.

You and Fuku-chan are pleased that she has submitted to you. Master removes your collars. You hop over to the baby macaque that Mistress's sister is nursing with a bottle; he's wearing a green "Long Beach Contest" jumpsuit made for a human newborn. It's going to be a full house – Master is raising two others to help wait tables.

Miyuki Hon-cho 4688,
Utsunomiya,
Tochigi, Japan
Nearest station
Utsunomiya
(an hour from Tokyo
Station by bullet train)
Open
Daily (6pm-late)
Telephone
028-662-3751

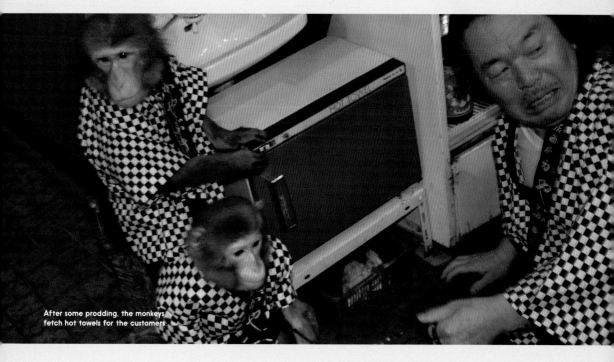

After some prodding, the monkeys fetch hot towels for the customers.

94

Your brother shoves you; you swat him back and scamper up a column, which is the closest thing here to a tree. "Hey, hey!" Master wants you to sit quietly in your wood stump chairs.

He taps the heater door with a long stick; you remove a hand towel wrapped in plastic and hand it to one of the regulars, who leans in for a kiss. The girl wants to take better pictures, so you have to do it again. And again. It's fun and you're rewarded with boiled soybeans, but it does make you wonder. You've done other impromptu imitations — like the time you guzzled a glass of beer and most of it went on the floor — and Master never asked you to repeat them.

"Do the waiters do other tricks?" the girl asks. Master leads you to bamboo-barricaded stage in the back room. You screech at Fuku-chan and jump into the toy bin; Master makes you come out. He ties hand-kerchiefs around your heads and baskets around your waists so that you look like Japanese fisherwomen. He covers Fuku-chan's face with a goofy *hyottoko* (fire-blowing character) mask and puts on a traditional folk CD. Master throws plastic eels and fish, and you catch most of them in your basket. "Ka-wai-EEE! Ka-wai-EEE!" shrieks a female customer.

Master replaces your headkerchief with a pointed straw hat. He strikes a drum and you sway left and right, lifting and lowering a round hat decorated with red flowers. "Ka-wai-EEE! Ka-wai-EEE!" the woman keeps shrieking.

Master takes out a plastic cone and a basketball. Fuku-chan stands on the basketball and Master tosses him rings. One by one, your brother catches them with his hands, then totters forward on the ball to throw them over the cone. He slips and falls on his back; the humans burst out laughing. "Ka-wai-EEE! Ka-wai-EEE!"

Master tells Fuku-chan to do back-flips and somer-saults. He holds your legs down and you demonstrate sit-ups and push-ups. "Sexy pose!" he calls. You and Fuku-chan lie on your sides and raise your legs up and down, up and down. You don't know why this is so amusing to them. Maybe it's because you're both wearing diapers?

There's no time to show off your karate and boxing skills. "The monkeys are only allowed to work two hours a day because of labor regulations," Master tells the girl. Mistress hand-feeds you vegetables; she strokes your heads and calls you her children. Every family has its squabbles, but you make this couple happy and your life at the tavern is a good one.

The girl waves goodbye: "If I had pet monkeys, I'd dress them in veils and make them dance to The Cure." You wonder what it would be like to live with her; if she has palm trees in her bedroom for you to climb...

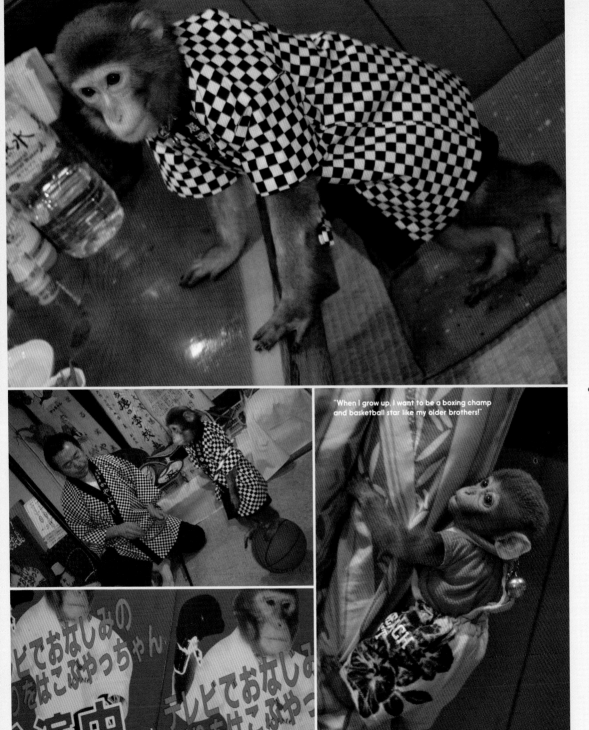

"When I grow up, I want to be a boxing champ and basketball star like my older brothers!"

Crazy, Wacky Theme Restaurants: Tokyo
By La Carmina

Design: Carolyn Frisch
Typefaces used: Hiruko, Neon

Library of Congress Control Number: 2008940208

Printed and bound in China by Asia Pacific Offset

10 9 8 7 6 5 4 3 2 1 First edition

This edition © 2009
Mark Batty Publisher
36 West 37th Street, Suite 409
New York, NY 10018
www.markbattypublisher.com

ISBN: 978-0-9820754-1-8

Distributed outside North America by:
Thames & Hudson Ltd
181A High Holborn
London WC1V 7QX
United Kingdom
Tel: 00 44 20 7845 5000
Fax: 00 44 20 7845 5055

www.thameshudson.co.uk